PLUG IN with NIK SOFTWARE

**A Photographer's Guide
to Creating Dynamic Images
with Nik Software**

John Batdorff

Peachpit
Press

Plug In with Nik: A Photographer's Guide to Creating Dynamic Images with Nik Software
John Batdorff

Peachpit
www.peachpit.com

To report errors, please send a note to errata@peachpit.com
Peachpit is a division of Pearson Education.

Acquisitions Editor: Ted Waitt
Project Editor: Susan Rimerman
Production Editor: Lisa Brazieal
Development/Copy Editor: Anne Marie Walker
Proofreader: Emily K. Wolman
Indexer: James Minkin
Composition: WolfsonDesign
Interior Design: Mimi Heft
Cover Design: Aren Straiger
Cover Photograph: John Batdorff

Notice of Rights

Notice of Liability

The information in this book is distributed on an "As Is" basis, without warranty. While every precaution has been taken in the preparation of the book, neither the author nor Peachpit shall have any liability to any person or entity with respect to any loss or damage caused or alleged to be caused directly or indirectly by the instructions contained in this book or by the computer software and hardware products described in it.

Trademarks

ISBN-10: 0-321-83977-3
ISBN-13: 978-0-321-83977-0

9 8 7 6 5 4 3 2 1

Printed and bound in the United States of America

Acknowledgments

To Staci and Anna, thank you for being so very supportive during this entire project. Sure, the two of you had fun with your dismissive jabs, such as "Don't you have a book to write?" This may have been hurtful to a more delicate ego. Well, girls, the book is done. Now you have 100 percent of my attention, which means I'm bugging ya 24-7-365 and it's payback time. Giddy up!

To Susan Rimerman and Ted Waitt, I don't think I could have asked for a more talented group of editors to work with, and I truly appreciate all your feedback during this entire process. I honestly love working with both of you—almost equally!

To Anne Marie Walker, thanks for editing my work and reminding me on a daily basis why I received a C– in Grammar. Thanks for catching all my mistakes. You're a rock star.

To Lisa Brazieal, thank you for taking care of me and making my images look great. I appreciate everything you and your team does.

To the Peachpit crew, thanks for believing in me. It's always a pleasure working with professionals.

Finally, a very special thanks to the readers of this book. I hope you enjoy it, and if you have any questions, feel free to drop me a note via my blog at www.johnbatdorff.com.

Contents

Introduction

Although digital processing can be enjoyable, I'm a photographer at heart, and my number one goal is to take more images and spend less time processing. I've always been drawn to solutions that help me achieve my vision without bogging me down in a technical labyrinth. Many years ago I bought Nik Software's Color Efex as my first plugin, and I've never looked back.

I love when photography and technology come together to create a product that's easy to use yet remarkably powerful. By utilizing proprietary algorithms and patented U-Point technology, Nik Software has done just that by providing photographers with a software suite that is second to none. Not only is the suite wrapped with a beautiful interface that's easy to operate, but it's also packed with powerful features that help you bring your vision to life.

U-Point Technology

At the heart of Nik Software is its propriety U-Point technology, which analyzes an image based on its attributes, such as hue, saturation, brightness, red, blue, green, and texture. Using this technology in conjunction with unique algorithms, Nik provides photographers with amazing creative control over their images. You'll use U-Point technology in depth in this book.

Advanced Photoshop Techniques

Each chapter explains the individual plugins, but I also delve into more advanced techniques, such as Adobe Photoshop layers and Smart Objects later in the book. These techniques take your editing to the next level to help you gain even more creative control over your images.

How to Approach This Book

This book has been written as a reference tool for new and established Nik Software users. Although you can jump from chapter to chapter, I've broken down the chapters based on a recommended workflow, starting with Dfine and finishing with Sharpening. Each chapter is a self-contained unit because not all users will own every plugin in the suite. With that said, some user interface controls are common between plugins and therefore are discussed in each chapter. After exploring the interface in detail, I move on to using the techniques in real-world editing. I provide step-by-step guidance on how to use the most efficient editing techniques, as well as some more creative uses for the tools and presets.

As you read along, I share several Hot Tips with you so that you get to know my favorite tips and techniques. You'll also find my Top Ten lists at the end of a few chapters. These are quick reference guides that share what I think are the most important pieces to remember about each suite.

Resources

Make sure to register your book at www.peachpit.com/nikplugin to access special bonus content. Look for the "Register your product" link. Make sure you login to your Peachpit account (or create one and login). After you complete the registration process look for your bonus content in the "My Registered Products" tab. You'll have access to additional learning aids as well as a few of my presets. I've also provided several images so that you can follow along with my workflow step by step as we process these images together. The images are strictly for educational purposes, but the presets are yours to use. I also share some videos with you for more in-depth and complicated processing techniques. By signing up for Peachpit TV (www.peachpit.com/podcasts), you can watch several videos of me using Nik to process some of my favorite images. And for even more free preset downloads, visit my blog at www.johnbatdorff.com/nikpresets.

The Future of Nik Software

At the time of this writing, Google purchased Nik Software and took ownership of its entire suite of plugins. The future of Nik is somewhat speculative, but Google has made public reassurances that it will continue to support and provide professional plugins for the photography community. I'm sure you will see Nik's technology deployed in some fashion in the years to come, but what form it will take is anyone's guess.

Experiment and Have Fun

Don't be afraid to make a few mistakes and venture off the path. It's via these experiments that you find our own vision. While you review this book, remember that my vision might not be shared by you, but my hope is that the images and process will spark your creative fire. Keep in mind that if you're not enjoying the process, you won't be happy with the outcome, so relax and have some fun.

"Lost in the Moment," New York City Subway, 2012

Canon 5D Mark II 48mm 1/50 @ f/2.8 ISO 200

DFINE 2.0

Dealing with a "noisy" image is nothing new: Back when film was your only option, you would have written off the images as grainy and tried to do better next time. With the advent of the digital sensor, you are still dealing with noise but to a much lesser extent. You also have far greater options for reducing noise in postprocessing. Regardless, whether you're an amateur or professional photographer, there's one thing for sure: You've had to deal with digital noise from time to time. How you handle that noise might help separate the former from the latter, but it's fair to say that digital noise can happen to the best photographers, especially in low-light conditions. The goal of this chapter is to explain what causes noise, provide steps to decrease noise during image capture, and describe how to reduce noise in postprocessing with Dfine.

Noise reduction doesn't always have to be a reactive tool for fixing poor exposure; instead, it can be a fun part of the creative process. This chapter starts off with some tricks on how to use Dfine to make selective adjustments and then illustrates some unintended uses for noise reduction, such as skin smoothing. Let's get started and discuss what all this noise is about.

What Is Digital Noise?

You can think of noise as the digital equivalent of film grain. It's most noticeable in areas that are intended to be smooth, such as a sky, but instead of appearing smooth, the area appears "grainy" or pixelated. When zooming in at 100 percent, you may notice the grain, or noise. This is when you need to consider using Dfine to reduce the noise and give the image the smooth look that you intended (**FIGURE 1.1**). Generally speaking, noise is an artifact you want to avoid in an image, but how much noise is acceptable really depends on your level of tolerance; one person's unwanted noise is another person's artistic treasure. Typically, I'll avoid noise at all costs when it comes to my color work, especially landscapes, but tend to be more tolerant in my black-and-white work. In black and white it can mimic a traditional film appearance, which may be a desirable quality.

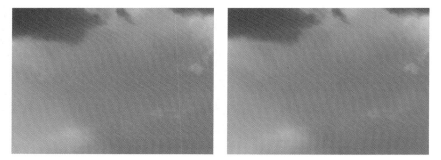

FIGURE 1.1 Compare the grainy image on the left (no noise reduction) to the same area on the right (noise reduction applied). The area on the right is noticeably smoother.

How Noise Is Created

Understanding noise and what creates it can be as dry as memorizing the Periodic Table of Elements. But there are some basics that you should understand so you can help reduce noise before it reaches the postprocessing stage.

Your camera's sensor is made up of thousands of photosensitive pixels that are used for recording your camera's signal. Large sensors generally produce less noise because the photosensitive pixels are much larger than those on a small sensor; thus, they have more room to record their information. A small sensor, like that of a compact camera, has less space for the pixels, so they become crammed together. I like to compare a small sensor to a house party gone awry. As result of this overcrowding, more heat is generated, which leads to increased noise (**FIGURE 1.2**). As I'm sure you've already guessed, larger,

high-quality sensors cost more than their smaller counterparts. Under ideal conditions, such as a bright day when you're using a low ISO, you might not notice a huge difference between sensors. However, once you increase the ISO or take a long exposure, the sensor's pixels become more sensitive, generating more heat, thus creating more noise. Under these circumstances a small, lower quality sensor will generate more heat and noise than its big-brother counterpart.

FIGURE 1.2 This image simulates the increase in noise from a higher ISO in cameras with smaller sensors (such as a compact camera).

Types of Noise

Noise is a combination of variations in luminance (contrast) and chrominance (color), and can vary between camera models.

Luminance, or contrast noise, is most noticeable in smooth tones, such as skies or skin, and most resembles film grain (**FIGURE 1.3**).

Chrominance, or color noise, creates red, green, or blue spots that are noticeable in a color image and are often referred to as unwanted artifacts (**FIGURE 1.4**). These artifacts are very noticeable in the color region and edges of an object. Long-exposure night photography almost always creates color noise.

FIGURE 1.3 Notice the how the image looks grainy.

FIGURE 1.4 The artifacts look like little color squares throughout the image.

Understanding Dfine

The great thing about using Nik Software's Dfine plugin is that it nearly runs on autopilot. Simply launch the program, let it run, and if the noise reduction is satisfactory, click Save and you're done. Easy peasy. Sometimes, however, autopilot doesn't work and you need to bring the bird in for a landing manually. That's what this chapter is really about, so let me explain in more detail how Dfine works.

Upon launching Dfine, it automatically scans your image, identifying wanted versus unwanted details. It marks the unwanted details, or noise, with Measurement Rectangles and then applies noise reduction based on the profile Dfine's algorithm has created.

When to Reduce Noise

You should reduce noise at the beginning of your workflow prior to image edits and then again at the end of the edit to ensure that noise hasn't been introduced via structure, clarity, and so on. Adobe Lightroom has made huge advances in noise reduction since Dfine was originally introduced, so if my noise reduction requires a quick fix, I complete the process using Lightroom. But for the more involved refinements, I always find myself in Dfine.

You might ask how much noise is too much noise? Well, as mentioned earlier, the answer is very subjective. You can resolve this question by asking two simple questions: Does the noise have any artistic value? How large will I print this image?

The first question helps determine if the noise adds to the overall vision you have for an image. Ninety percent of the time the answer is no.

If you determine that you will make a large print of the image, keep in mind that any noise becomes amplified as it's enlarged. For example, I recall seeing a billboard in Chicago promoting Yellowstone National Park, but the photographer hadn't removed the noise from the sky. The image had pixels the size of a Chicago deep-dish pizza; it was incredibly distracting.

So determine what the intended use of the image will be. If you're using a low-res image on the Web, chances are you really don't need to worry about being too fanatical with noise reduction. But if your image will be printed, remember that the larger the print, the more obvious noise becomes, even in an 8x10 image.

Why wouldn't you just apply noise reduction all the time? Better safe then sorry, right? Nik's Dfine is a wonderful tool, but like all noise reduction methods, it comes with trade-offs, including loss of sharpness. Whenever you apply noise reduction to an area, it tends to make the affected area appear softer. In the landscape image in **FIGURE 1.5**, you expect the clouds to be soft or smooth, so noise reduction is a good way to achieve this goal. However, applying noise reduction to the mountains makes the image look unnatural. This is a prime example of when you would apply noise reduction selectively, which I'll demonstrate later in this chapter.

FIGURE 1.5 The goal was to reduce noise in the clouds while maintaining detail in the mountains.

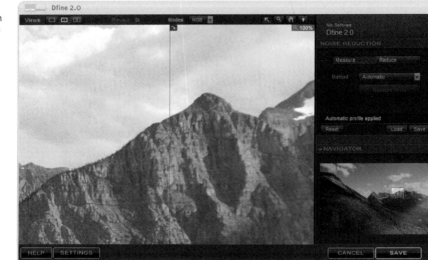

Getting Started with Dfine

To show you how to use Dfine, I chose a nice yet noisy sunset shot from Jamaica to work on together, so make sure you register your book and download the file noisysunset.tif (**FIGURE 1.6**) at peachpit.com/nikplugin. Launch this image using your favorite host program; in my case it's Lightroom (**FIGURE 1.7**) or Photoshop. Keep in mind that the biggest advantage to using Photoshop is the ability to brush on noise reduction effects and use Smart

Objects. I'll demonstrate brushing on noise reduction in this chapter, and Smart Objects in Chapter 7, "Advanced Techniques in Photoshop."

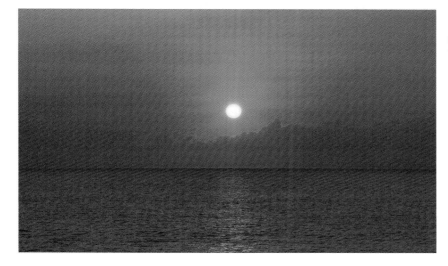

FIGURE 1.6
Low-light conditions are a breeding ground for noise.

FIGURE 1.7 To export an image out of Lightroom and into Dfine, press Ctrl+Alt+E (Command+Option+E).

Measuring Noise:
Automatic vs. Manual

As soon as it launches, Dfine automatically goes right to work by identifying and measuring areas of the image that contain undesired details or artifacts. Once identified, Dfine marks these locations with Measurement Rectangles and uses these locations to help create a noise reduction profile (**FIGURE 1.8**). Most of the time, these automatic settings do a very nice job of reducing noise while retaining detail where you need it. But just like any automatic feature, it doesn't always get it right, and sometimes Dfine will select areas that you don't want to be part of the noise reduction profile. That's why you have the ability to measure noise manually by making adjustments to the Measurement Rectangles. You can adjust any of the Measurement Rectangles by selecting or moving them, changing their size, or even deleting them completely.

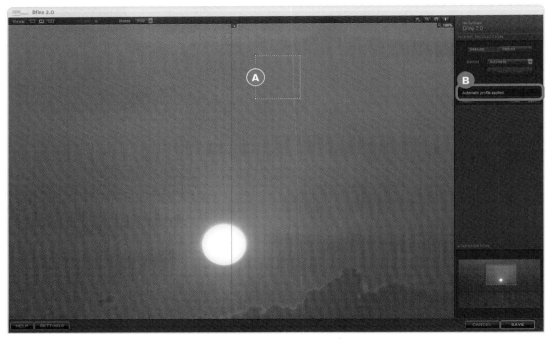

FIGURE 1.8 Dfine marks artifacts with Measurement Rectangles (A) and creates an automatic noise-reduction profile (B) immediately after analyzing your image.

In addition, you have the ability to add completely new Measurement Rectangles. To do this, select Manual Method, click the Measurement Rectangle tool icon, and locate the place on your image where you want to reduce noise. Then draw in a new rectangle (**FIGURE 1.9**).

FIGURE 1.9 Use Manual Method to override Dfine's automatic measurement settings.

USING MEASUREMENT RECTANGLES

You *should* consider placing Measurement Rectangles on:

- Sky
- Skin tones
- Buildings or walls that you would expect to be smooth
- Different tonal or color areas throughout the image

Do *not* place Measurement Rectangles on:

- Areas with a lot of texture or detail
- Areas with hard edges
- Areas of foliage or grass
- Areas that are almost 100 percent white or 100 percent black

At any point during the noise reduction process you can ask Dfine to create a new noise profile by clicking the Measure Noise button (**FIGURE 1.10**). And if you want to start over, simply click the Reset button. Just remember that Reset will remove all the Measurement Rectangles and you'll be back at square one!

FIGURE 1.10 Click the Measure Noise button anytime that you want to create a new noise reduction profile.

Previewing Noise Reduction

Now that you know how to measure noise, you need to know about preview options (**FIGURE** 1.11).

By default, an image opens in the Single Image view when the Preview box is selected. Single Image view displays the entire image with a preview of the automatic noise reduction applied to the image. Keep in mind that this is a preview only, and nothing has been saved to the image until you click Save in the bottom-right corner of the interface. I rarely use this view to begin the image evaluation process. Instead, I prefer either the Split view or Side-by-Side view because they provide a before and after view of the noise reduction effects.

FIGURE 1.11 Change your view by clicking any of the three preview options: Single Image view (A), Split view (B), Side-by-Side view (C).

After you've selected Split view, use the Zoom tool (or press Z) (**FIGURE** 1.12) to scan your image to determine the net effect of the noise reduction to select areas. Even if you agree with Dfine's selection of noise indicated by the Measurement Rectangles, you might not want to apply noise reduction to the entire image (I rarely do). Instead, use Control Points, which we will discuss later in the chapter, to determine which areas will receive noise reduction.

FIGURE 1.12
To magnify your view, select the Zoom tool or press Z.

Select the Hand tool in the top right of your screen (**FIGURE** 1.13), or press H, to pan around your image and evaluate the noise reduction. An alternative to using the Hand tool is to use the Navigator window (**FIGURE** 1.14), which allows you to jump around to specific regions of your image effortlessly by moving the red outlined box.

FIGURE 1.13
To pan your image, select the Hand tool, or press H.

FIGURE 1.14 Use the Navigator window to pan quickly to select areas of an image.

Using modes to view noise

You have several different ways to visualize how Dfine is affecting your image by using different Preview Modes (**FIGURE 1.15**). I strongly recommend making most, if not all, of your noise reduction decisions using the RGB mode because it provides the best visual aid for understanding how the final image will look when noise reduction is applied. However, the more advanced Preview Modes can provide you with additional knowledge about the noise and how it's being reduced.

Preview: ☑ Modes: RGB ▼

FIGURE 1.15 Use the drop-down menu to select the desired Preview Mode.

RGB mode is the default view and provides you with the best overall sense of how the noise reduction will be applied to an image. Use this view in the beginning when evaluating your image for noise as well as in the final review prior to applying any noise reductions.

Red, Green, and Blue modes will display in grayscale the amount of noise and/or reduction taking place in each color channel. This is helpful when you want to fine-tune the noise reduction using manual reduction technique tools, such the Color Range sliders or Control Points. Also, noise can vary greatly by color channel, and some filters or camera models increase the amount of noise in any given channel, so using the Red, Green, or Blue mode can help identify areas of concern (**FIGURE 1.16**).

FIGURE 1.16 Using the Red Preview Mode allows you to see the noise in that particular color channel.

Luminance mode displays in grayscale the effects of the noise reduction in the light to dark areas of an image. It can be a helpful tool when evaluating the effects of the Contrast slider (**FIGURE 1.17**).

Chrominance mode displays in grayscale the effects of the noise reduction in the color elements of your image.

FIGURE 1.17 Select either the Luminance or Chrominance mode to help identify noise further. Use the Contrast Noise Mask or Color Noise Mask to help identify noise further when using selective noise reduction.

Contrast Noise Mask and Color Noise Mask are probably two of the most useful Preview Modes beyond RGB. They are created whenever the Control Point or Color Range tools are employed. Remember that whenever you're working with a mask, black hides and white reveals, so the areas in black are not affected by the noise reduction, whereas the areas in white are affected by the noise reduction. The areas in gray will receive some effects of the noise reduction filter (**FIGURE 1.18**).

FIGURE 1.18 Use the Contrast Noise Mask or Color Noise Mask preview to see how noise reduction is being applied.

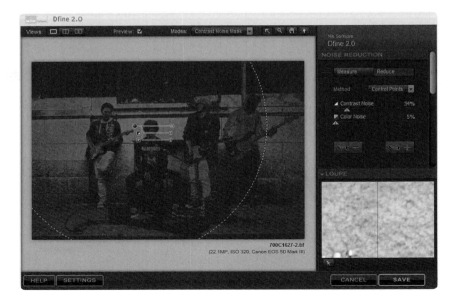

Reducing Noise

When you're using Dfine, your goal is to reduce noise judiciously and avoid applying noise reduction to areas that don't need it. You can achieve this goal by using one of two methods: Control Points or Color Ranges. Let's explore the benefits of each method.

Control Point Noise Reduction

The Control Points method is the default technique used by Dfine to reduce noise after it has been measured. This technique uses two basic global sliders to control Contrast and Color noise, as well as more refined selective adjustments. The major benefit to using this technique is that it's very easy to use and visualize the net effect. Simply put, there's a reason Nik makes this the default setting.

The global tools

The Contrast Noise slider (**FIGURE 1.19**) is used to address noise found in the contrast or luminance regions of an image. If you remember from earlier in the chapter, this type of noise looks like grain and appears in areas that should be smooth, such as skies or skin tones. The slider is set at 100% by default but can be increased or decreased to address noise. Keep in mind that when you increase the slider, it will make the image look softer or "smoother," which means detail is being sacrificed. Increase this carefully.

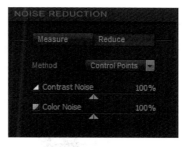

FIGURE 1.19 Use the sliders to adjust noise manually.

The Color Noise slider is used to address color noise that's unmistakably marked with red, green, and blue flecks in areas that shouldn't contain any color noise. This slider works much like the Contrast Noise slider and can be adjusted as needed. In many cases, the 100% default works fine, but in some cases you may need to increase the slider toward the 200% mark. Be aware that as you increase the Color Noise slider, it's possible to cause a reduction in the saturation of brightly colored objects. If you do experience this problem, simply reduce the Color Noise slider until you've achieved a balance of noise reduction and adequate color saturation.

Selective adjustments

Sometimes, too many options can lead to paralysis of analysis. Instead of spending too much time on sliders, spend more of your time making sure Dfine has a good Measurement Rectangle for your noise reduction profile, and then use Control Points (**FIGURE 1.20**) to identify regions of your image that should or should not receive noise reduction. If you're not using Photoshop to brush on your effects, this is where you should focus your due diligence.

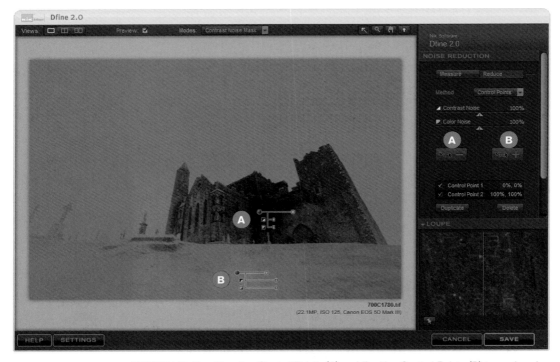

FIGURE 1.20 Use Negative Control Points (A) and Positive Control Points (B) to apply noise reduction selectively.

Control Points are Nik Software's patented U-point technology (see "Introduction" at the beginning of the book) and is used to identify specific areas of an image where you want to place your effects. It allows you to make surgically precise selective adjustments to an image by telling the filter where to apply an effect and where to avoid applying the filter. In a nutshell, it's a highly intuitive masking tool.

Let's review your Control Point options:

- **Negative Control Point.** This is the Control Point type you'll use most often because by default Dfine has already applied noise reduction, so in many cases your goal should be to turn it off or lower the opacity (the filter strength) on certain parts of the images.

- **Positive Control Point.** This is the Control Point you use if you need to increase the noise reduction in specific regions on an image. By default, a Positive Control point's opacity is set at 100%, meaning noise reduction is being applied at 100%.

Selective adjustment exercise

Now that you understand the basics of using Control Points, let's run through an example using an image of an Indian woman I photographed in Varanasi, India. The noise reduction of this image is fairly satisfactory, but it would be better to lower the opacity of the filter on her face because the current setting is making it a tad too soft.

1. Select a Negative Control Point and use the Loupe view to help locate a desirable spot to establish as your center point.

2. Use the Contrast Noise slider (**FIGURE 1.21**) to establish the desired effect and increase the filter opacity while reviewing the net effect in Loupe view. A value of 35% looks pretty good and is a nice balance between retaining detail while reducing noise.

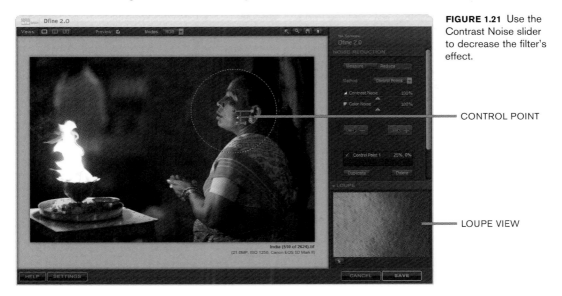

FIGURE 1.21 Use the Contrast Noise slider to decrease the filter's effect.

CONTROL POINT

LOUPE VIEW

Upon closer inspection of the image, the background near her face is still showing a bit too much noise.

3. Place a Positive Control Point on the background and increase the Contrast Noise slider to 130% to further reduce the noise (**FIGURE** 1.22). Be sure to make small adjustments and review the effect in Loupe view.

FIGURE 1.22 Place a Positive Control Point on the area you want to apply or increase noise reduction.

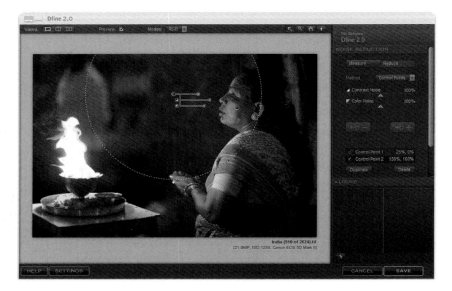

4. Review your adjustments by switching to the Contrast Noise Mask mode (**FIGURE** 1.23). To do this, click Modes and use the drop-down menu to select Contrast Noise Mask.

 As you can see, the Control Points have done a pretty nice job of making the appropriate mask for each selection. The gray area represents noise being applied at 100%, the darker areas mean less noise reduction is being applied, and lighter or brighter areas mean more noise reduction is being applied.

5. Switch the Mode back to RGB to review the final image before saving it, and voilà, you're done!

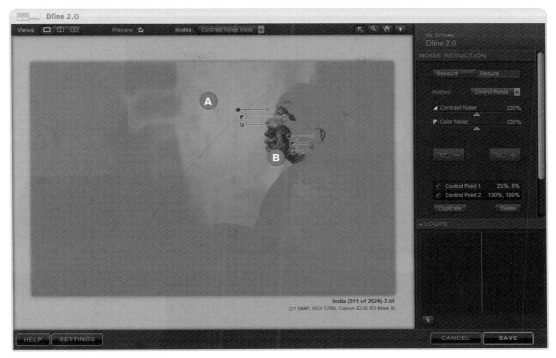

FIGURE 1.23 The light or white area (A) noise reduction is being increased, and the dark or black area (B) noise reduction is being reduced.

Color Range Noise Reduction

The Color Range noise reduction tools can be very effective for making selective adjustments to isolated colors. The minimum color selection required is two with no cap on the amount of selections you can make. Let's review the benefits of using the Color Range panel by opening my favorite Sleeping Hippo image in Dfine. You can find the file Sleepinghippo.tif at peachpit.com/nikplugin. You'll use Dfine's Automatic profile that was created at startup (**FIGURE 1.24**).

FIGURE 1.24
An Automatic noise
reduction profile is
generated based on
the locations.

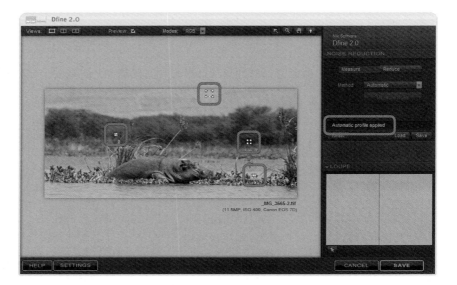

1. Click the Reduce panel button and select Color Ranges from the Method drop-down menu (**FIGURE** 1.25).

2. Select the first eyedropper and place it on the area of the hippo where you don't want noise reduction applied. Remember that often noise reduction means loss of detail.

3. To make this a little easier, zoom in by selecting the Magnifying glass (or press Z) and clicking the area you want to enlarge. Use the next available eye-dropper or click the plus (+) sign to add a new one. Now select the area of the hippo where you want to retain detail.

FIGURE 1.25 Use the Color Range method to reduction noise in specific colors.

4. Adjust the Contrast and Color Noise sliders to 0% to remove any noise reduction (**FIGURE 1.26**).

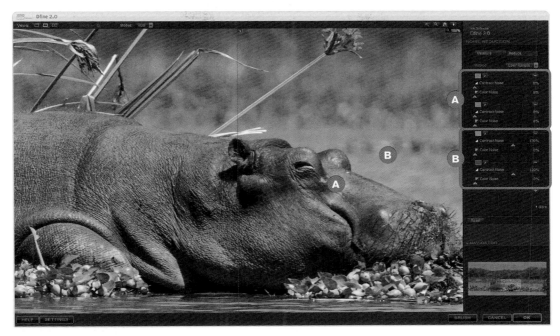

FIGURE 1.26 Use the eyedroppers to select colors you want to islolate for noise reduction treatment. We decreased noise reduction on select colors (A) and increased noise reduction on select colors (B).

5. You may notice that some noise has entered back into the image, so add a few additional Color Noise sliders by clicking the plus (+) sign and selecting areas of the image that need some noise reduction.

 I made three selections: dark green from the background, blue from the water, and brown from the stem over the hippo's head.

6. Because there isn't any color noise, concentrate on making adjustments to the Contrast Noise sliders only.

7. Finish by adjusting the sliders to your taste while trying to balance noise reduction with loss of detail.

Expanded Noise Reduction Options

At the bottom of the Noise Reduction panel is an option to expand the panel by clicking the disclosure triangle next to the word More (**FIGURE 1.27**). Let's review these advanced options:

FIGURE 1.27 Click the disclosure triangle to access more advanced noise reduction features.

- **Edge Preservation.** This tool should be used only when you've applied Contrast Noise reduction to area of an image that needs to maintain edge detail. It helps reduce the blurring effect of the Contrast Noise reduction by sharpening the edges of the object. To activate this tool, select the check box next to Edge Preservation and use the slider to increase the necessary details, but be aware that any existing noise near the edges can be amplified by the sharpening process. Use this feature only if adequate noise reduction has been applied (**FIGURE 1.28**).

- **JPEG Artifact Reduction.** This tool should be used with JPEG files only and will help reduce the square boxes that can occur whenever you save an image as a JPEG. Typically these artifacts are introduced when an image has been resized and/or has been saved as a high-compression JPEG file (**FIGURE 1.29**).

- **Debanding.** This tool reduces color-banding artifacts that present as either horizontal or vertical aberrations. Identify the direction of the banding in your image first, and then increase or decrease the horizontal or vertical slider as needed (**FIGURE 1.30**).

FIGURE 1.28
Use Edge Preservation
when you want to
maintain detail around
the edges of an object.

FIGURE 1.29 Loss of detail
in the edges and pixelated
boxes are signs of JPEG
artifacting.

FIGURE 1.30 Sometimes
viewing your image as
grayscale can help identify
banding.

Photoshop's Selective Tools

The Selective Tools panel is where the real power and flexibility of owning Adobe Photoshop or Adobe Photoshop Elements come into play. With the click of a button, Selective Tools (**FIGURE 1.31**) automatically generates a layer and an accompanying layer mask, giving you the freedom to apply Dfine 2.0 or any of the seven noise brushes.

FIGURE 1.31 To apply noise reduction while in Photoshop, in the Selective Tools panel click Dfine or any of the seven noise brush presets listed in the sidebar "Seven Noise Reduction Brushes."

SEVEN NOISE REDUCTION BRUSHES

- **Dfine 2.0.** Click this brush to launch the Dfine interface, which allows you to make appropriate noise reductions while in the interface and later brush those effects on the image.

- **Background Noise Brush.** Use this brush to help reduce noise that is prevalent in the background of an image.

- **Hot Pixels.** Use this brush to eliminate bright noise spots, or hot spots, that appear usually in a shadow region of an image. Often, this can occur with images that have been taken at night.

- **Fine Structures.** Use this brush on areas where you need a nice balance between retaining detail and reducing noise, such as hair.

- **Skin.** Use this brush to reduce contrast and color noise while maintaining fine-detail structures that may exist. For example, it is very helpful in smoothing skin without giving it that overly smooth or plastic look.

- **Sky.** Use this brush to reduce chrominance noise and smooth noise artifacts that appear in the sky.

- **Shadows.** Use this brush to reduce noise in the shadow and low-light regions of your image.

- **Strong Noise.** Use this brush as a last resort. It's very effective in reducing strong contrast noise from high ISO images while maintaining as much detail as possible.

Getting Creative

The Selective Tool Skin brush not only reduces noise, but also aids in softening skin. To be honest, sometimes I'll use it strictly for softening skin in black-and-white images, even when there's no visible noise. This is my preferred method because it leaves behind a soft yet realistic skin tone. Let's work through an exercise applying the Skin tool. In Photoshop, open the file skinsmoothing.tif, which you can download at peachpit.com/nikplugin (**FIGURE 1.32**).

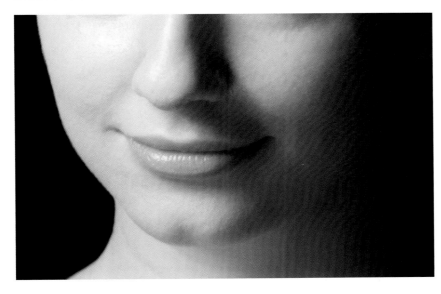

FIGURE 1.32 Apply the Skin tool to smooth out areas around the woman's chin and cheeks.

1. Select the Skin brush from the list of Selective Tools (**FIGURE 1.33**).

2. Adjust your brush size accordingly by pressing the left bracket key ([) to decrease the size and the right bracket key (]) to increase it.

3. Begin to paint around the regions of the woman's face, and especially note how the skin begins to smooth out while still maintaining some detail.

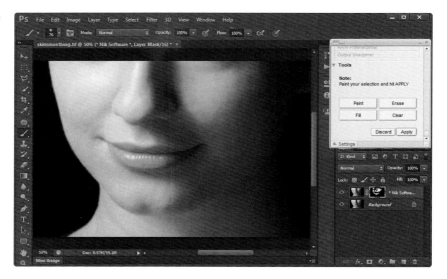

FIGURE 1.33 Using the Skin brush, paint the areas of the skin you want to smooth.

4. If you decide you don't like the effect, you can use either the Erase tool to brush over the areas where you want to remove the filter effect, or simply click the Clear button and begin painting again (**FIGURE 1.34**).

5. If you want to globally apply the filter effect globally to an entire image, click the Fill button and paint away the areas where you don't want the filter applied.

Remember that none of your adjustments are recorded until you click Apply. Alternatively, at any point in time that you want to exit, simply click Discard and the layer and mask will be deleted.

FIGURE 1.34 Use this panel to control the application of the brushes.

Looking Forward

Digital noise, although still a problem, isn't nearly as prevalent as it once was. Sensor technology has improved, fewer professionals are shooting JPEG files, and raw conversion has made noise reduction easier to eliminate. But as more and more photographers are pushing the limits of ISO, chances are you'll be dealing with noise for some time to come. If you're a Photoshop user, be sure to check out Chapter 7 where I'll incorporate noise reduction in a few of the exercises while using Smart Objects.

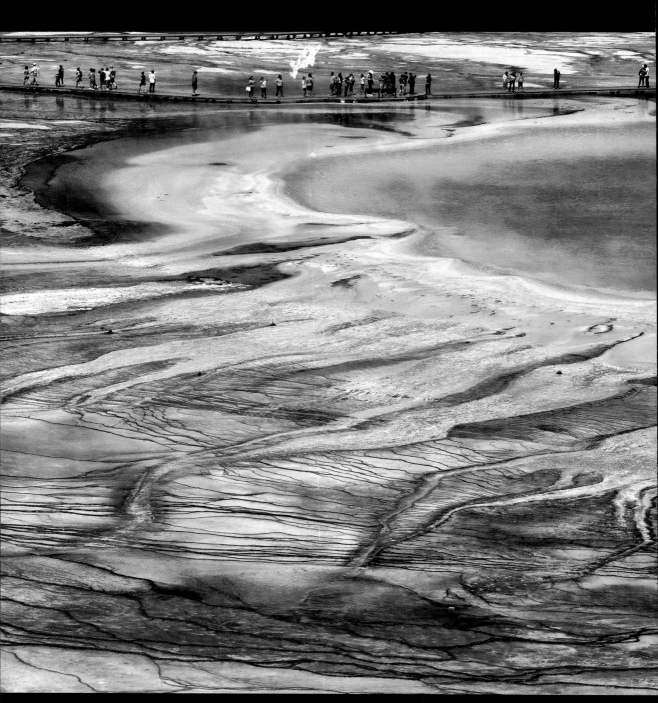

Grand Prismatic Spring, Yellowstone National Park, 2011

Canon 5D Mark II 140mm 1/125 @ f/13 ISO 160

Chapter 2

VIVEZA 2

If you like what Silver Efex Pro has done for your black-and-white work, then you'll love what Viveza will do for your color work. Viveza is one of Nik's most straightforward plugins, providing you with easy-to-use tools and allowing you to take control of your image's color, brightness, contrast, and so on. The real benefit of using Viveza is the precision and ability to make specific adjustments to an image's saturation, hue, or brightness without needing to create complex masks in Adobe Photoshop.

Viveza doesn't provide any presets to give you a visual cue as to what direction you should take with your images, so it's important to have some sort of focus in mind when you're working in Viveza. Spending extra time assessing an image and visualizing the end result can be incredibly helpful in establishing the creative path for your edits. The greatest aspect of Viveza is that you can use it at any stage in your editing process, but it's considered best practice to use it after applying noise reduction.

In this chapter I'll walk you through how to use Global and Selective adjustments with each of Viveza's ten Enhancement sliders. And I'll wrap up by reviewing how to use Viveza to correct problems, and to create better portraits and dynamic landscapes. So let's get moving!

My Workflow

I use Viveza as a creative tool for addressing very specific color needs in an image, such as saturation or contrast, or to shape the light of an image. Typically I'll use Viveza in conjunction with Adobe Lightroom, Adobe Photoshop, or other Nik plugins as part of a series of steps in creating my final image (**FIGURE 2.1**). But it's not uncommon for me to start and finish an image solely in Viveza.

FIGURE 2.1 Here I used Viveza to increase the saturation of the night sky after I applied a filter using Color Efex 4.

One of the great features of Viveza is the ability to use Control Points to shape the light. When I teach Silver Efex Pro, I often talk about using Control Points to dodge (lighten) and burn (darken) your images (**FIGURE 2.2**). This concept seems to be very easy to grasp in the black-and-white world, but in a color world it can be a bit confusing. One of Viveza's essential strengths is its ability to dodge and burn color, allowing you to shape the light and ultimately direct your viewers' eyes to what you feel is important in an image.

FIGURE 2.2 Use Viveza to shape the light using simple dodge and burn techniques.

Using Global Adjustments

The first difference you'll notice between Viveza and other Nik products is that the Global adjustments are located below the Control Points feature (**FIGURE** 2.3). Remember that Global adjustments affect the image as a whole, and Selective adjustments affect very specific regions of an image as outlined by the control points.

Typically, you'll make Global adjustments before making Selective adjustments to avoid unnecessary duplication, but Viveza's interface is laid out in a way that you'll be tempted to start placing control points immediately. My recommendation is to skip the temptation to use control points and make any needed Global adjustments first, such as Brightness, Saturation, or Warmth—especially if you'll be editing your image from start to finish in Viveza. If you've already made your Global adjustments in another program, such as Lightroom, or if no Global adjustments are needed, feel free to proceed to using Control Points.

FIGURE 2.3 Use Global adjustments to affect the entire image.

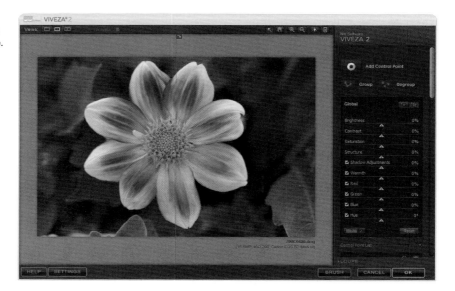

The Enhancement Sliders

Four basic Enhancement sliders are displayed by default, but to reveal all ten, you'll need to click the Expand button (**FIGURE 2.4**). Going forward, keep in mind that these ten sliders are the same tools made available to you as Selective adjustments. Let's review what these sliders do on a global level so when you move on to using Control Points, you'll understand how they interact as a Selective adjustment.

Brightness

Use the Brightness slider to increase or decrease the overall brightness of a scene. Move the slider to the right to increase brightness or to the left to decrease it. This slider works similarly to an Exposure slider by moving the entire histogram to the right or left as you make adjustments.

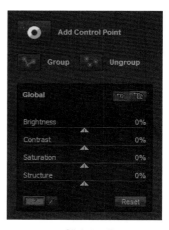

FIGURE 2.4 Click the Expand and Collapse buttons to toggle your slider view.

Contrast

Use the Contrast slider to increase or decrease the distinction between objects in a scene. Keep in mind that increasing or decreasing contrast will affect saturation and brightness, so I recommend that you make Global adjustments before making any Selective adjustments.

Saturation

Use the Saturation slider to increase or decrease the strength of a particular color (hue). I rarely use the Saturation slider as a Global adjustment, preferring instead to make these adjustments using Control Points. If you do plan on applying Saturation globally, I highly recommend making small adjustments with this slider to avoid oversaturation.

Structure

Use the Structure slider to increase or decrease small details in an image. Moving the slider to the right gives an image a feeling of texture by emphasizing the small details in the image. To create the opposite effect, move the slider to the left and the image will appear softer.

Shadow Adjustment

Use the Shadow Adjustment slider to increase or decrease the brightness of the shadow areas in your image. Unlike the Brightness slider that affects the overall exposure of the image, this slider primarily affects the dark, or shadow, areas of the image. I often use this slider to darken the background of an image versus using the Brightness slider to avoid darkening an image's overall brightness.

Warmth

Use the Warmth slider to adjust the overall color temperature of an image. You can use this slider to address white balance problems resulting from an unwanted color cast. Move the slider to the left to cool down the image or to the right to warm up the image.

Red, Green, and Blue

Use the Red, Green, and Blue sliders to fine-tune color cast problems or to create a unique creative effect.

Hue

Use the Hue slider to change the color of a specific object or that of an entire image.

Resetting the sliders

FIGURE 2.5 Use the Reset button to return all the sliders to zero at anytime.

At any point in time you can click the Reset button to zero out all of the sliders' effects (**FIGURE 2.5**). You may have noticed the Eyedropper tool with the question mark in the gray box. The Eyedropper tool works only when a control point is in use and you're making Selective adjustments. I'll bet you're wondering why it appears under Global adjustments. Well, I'm not sure. But I didn't want you to click it and wonder if you missed a step. Don't worry; you'll be using the Eyedropper tool in no time.

Using Control Points

Once you've made Global adjustments, you can then harness the real power of Viveza by using Control Points with U-Point technology. To avoid repeating information here, be sure to check out the "Introduction" chapter at the beginning of this book to learn more about how U-Point technology works. But for those of you who want to start kicking the tires and figuring out how to use Control Points, read on!

As mentioned earlier in the chapter, I primarily use Viveza to bring my vision to life by addressing my image's very specific problems or requirements. Control Points give me the exact control I need to address these problems without creating complicated masks or layers. Before explaining how I specifically use Control Points in Viveza, let's review how to use them effectively.

1. To add a control point, click Add Control Point while using the Loupe view to help you find the exact location to place your center of influence or focus (**FIGURE 2.6**).

2. Create a boundary circle to determine the area that will be affected by the control point.

3. Make adjustments using either the Control Point sliders or the Selective sliders in the panel on the right. At any point you can expand the Enhancement sliders option by clicking the triangle on the control point or clicking Expand in the right panel.

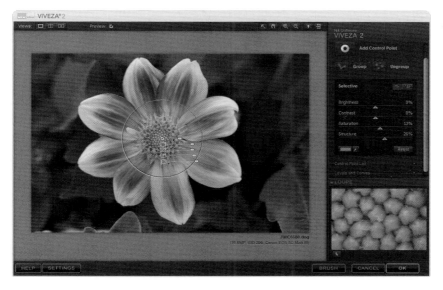

FIGURE 2.6 Use control points to make Selective adjustments.

Toggling Between Selective and Global Adjustments

After adding control points, you might want to make Global adjustments again. To do so, simply click your cursor anywhere on the image where a control point doesn't exist, and that will bring you back to the Global Adjustment panel. Keep in mind that the Global and Selective (Control Points) Adjustment panels look identical and use the same set of Enhancement sliders. To avoid any confusion, remember that for the Selective Adjustment panel to be active, a control point must be selected. The panel on the right will always indicate which Adjustment mode you're in: either Global or Selective (**FIGURE 2.7**).

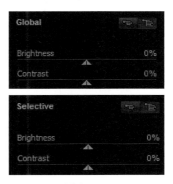

FIGURE 2.7 Make sure you know if you're making Global or Selective adjustments.

Creating Groups Using a Control Point List

The Control Point List is a snapshot of all the available control points in use throughout the image. Anytime you add a new control point or group, it will be displayed in the list. The list is helpful when you're creating groups that are performing a similar function. For instance, I often group control points that isolate the background or the sky.

Creating a group

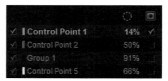

FIGURE 2.8 Group control points that perform similar tasks.

To create a group of control points, select the control points either on the image or in the Control Point List that you want to group while holding down the Shift key. When the control points are selected, click the Group button (**FIGURE 2.8**) or press Ctrl+G (Command+G). This creates a master control point for that one group. If you ever need to ungroup a selection, click the master control point and then click Ungroup or press Ctrl+Shift+G (Command+Shift+G). For a complete list of keyboard shortcuts see the list at the end of this chapter.

> **HOT TIP**
>
> While holding down your mouse button, drag your cursor across the control points you want to group. Once selected, press the keyboard shortcut or click the Group button to group them.

Show Selection box

The Show Selection box is a handy tool to identify which areas of your image the control point is affecting.

First, identify the control point you want to isolate: The Control Point List helps you identify control points by providing a color bar to indicate which control points are affecting which colors in a selection. The dotted circle represents the overall size of the region being affected, and the last box is the Show Selection box (**FIGURE 2.9**).

FIGURE 2.9 Use the Control Point List to help group and identify control points.

Second, click the Show Selection box to provide a mask of the areas that are receiving the filter's effect. Areas being affected by the selected control point appear in white, whereas areas not being affected appear in black (**FIGURE 2.10**). There are gray areas that are receiving some of the filter's effect. The benefit of using the Show Selection tool is to aid in troubleshooting any overspray. I always recommend toggling back to the color Preview mode to confirm that all adjustments are as you intended.

FIGURE 2.10 Use the Show Selection box to show a mask of your control point selection.

Using the Color Picker or Eyedropper tool

The Color Picker and Eyedropper tools work only when a control point is selected. Once a control point is selected, you can change the color of the selected object by either using the Color Picker or matching a color within the image using the Eyedropper tool.

For example, if I place my control point on something blue in the image, when I hover my cursor over the Color Picker box, it provides me with the current RGB color numbers (**FIGURE 2.11**). The RGB numbers are vital when exact color matching is critical.

FIGURE 2.11 Hover over the Color Picker box to see the RGB numbers.

When you select and click the Color Picker box, your host application's Color Picker tool will launch so you can select a color to change your selection to (**FIGURE 2.12**).

FIGURE 2.12 Use the host application's Color Picker to change or match control point color selections.

A practical application of the Eyedropper tool

Using the Eyedropper tool is an effective way to make a selection within an image. Let's look at the example in **FIGURE 2.13** of an HDR shot taken in Paris. I wanted to add a small reflection of the sunset on the water, so first I selected a control point and placed it on the water near the bridge. Then I created a relatively small boundary circle to begin with and expanded it until it was just right.

FIGURE 2.13 Remember to use the Loupe view to assist in placing your control points.

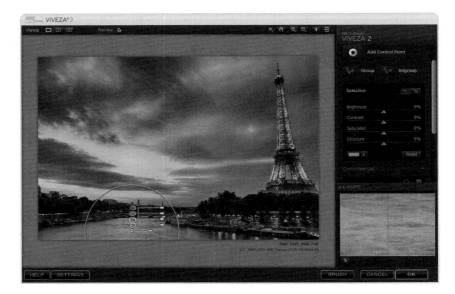

Next, while the control point was still selected, I clicked on the Eyedropper to sample the color in the sunset (**FIGURE 2.14**). Remember that whichever color you select will replace or blend in with your control point's selected area.

FIGURE 2.14
The Eye Dropper tool can be effective tool for modifying color.

Finally, I made some minor adjustments using the Enhancement sliders to create the optimal effect. You may need to adjust the Brightness, Saturation, and other sliders as needed to create your desired effect (**FIGURE 2.15**).

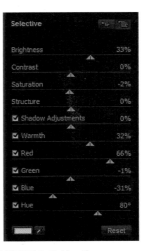

FIGURE 2.15 Use the Enhancement sliders to help create the desired effect.

Using Tone Curves and Levels

The tone Curves and Level adjustments should be some of the last adjustments you make to an image. I typically make most of my Levels and Curves adjustments in my host application (Lightroom or Photoshop), simply because I can be a bit fickle with my contrast adjustments and I like the ability to revisit these adjustments from time and time. Viveza's Levels and Curves work similarly to most other host applications, such as Photoshop.

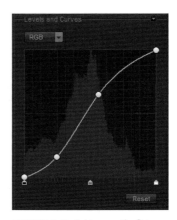

Create a gentle S shape in the curve to increase contrast within an image (**FIGURE 2.16**). To add an anchor point, click the curve and move the line up or down. To delete an anchor point, select the point with your cursor and double-click. To reset the curve, click the Reset button.

FIGURE 2.16 Add a gentle S to your tone curve to create natural-looking contrast.

> **HOT TIP**
>
> For an expanded explanation of working with the tone curve, review the section "Levels and Curves" in Chapter 4, "Silver Efex Pro 2."

Enhancing Your Landscape Images from Start to Finish

The difference between a good shot and a great shot is often how it's been processed. In this exercise I'll to show you how to take a flat image and make it pop off the screen. You can follow along by registering your book and downloading the sheep.tif file at www.peachpit.com/nikplugin. Open the image to follow along (**FIGURE 2.17**).

FIGURE 2.17
Analyze the image
and try to visualize
what path your editing
should take.

Remember that visualizing and understanding the direction in which you need to take your image is crucial to using Viveza effectively. Upon review, this image appears a bit flat so you'll want to increase contrast and saturation, and add a bit of texture to really make this image come to life.

Be sure to make all of the Global adjustments before you use Control Points. Before starting this exercise, let's expand the Global Enhancement sliders by clicking the Expand button at the top right of the Global Adjustment panel.

1. Increase the Contrast Enhancement slider to +20% (**FIGURE 2.18**). Notice that an immediate improvement is made in the image, but also notice the trouble areas being created by the Global adjustment. In this case the sheep's head has become even darker, so you'll need to use a control point to selectively address this problem later.

2. Move the Warmth slider to +5% to warm up this image a bit. The image is looking pretty good on a global level, so let's fine-tune the image using Control Points to make Selective adjustments.

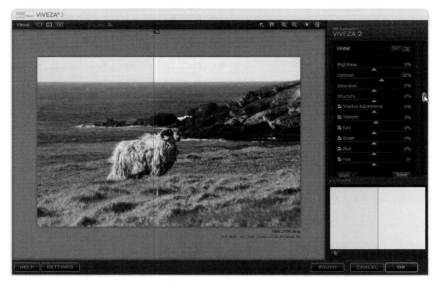

FIGURE 2.18 Note how the Global adjustments affect the overall image. Make a list of any areas that might need to be addressed with Control Points.

3. Now for the real fun. Let's use Control Points to dial in the saturation, contrast, and texture. Switch from Split Preview to Single Image view so you can see the entire image. If you need to zoom in at any point, you can use the magnifying glass at the top right, or press the spacebar.

4. Place the first control point (1) in the water in the background and create a boundary circle large enough to cover just the water (**FIGURE 2.19**). Then increase the Saturation slider until it looks good (13% seemed to do the trick). To avoid a cartoonish look, try not to oversaturate the color.

5. Place a second control point (2) on the green grass and increase the Saturation slider to +30%.

6. Place a third control point (3) on the rocks in the background and increase the Structure Enhancement slider to +40% and the Shadow slider to +20%.

7. Place a fourth control point (4) on the center of the sheep's body while drawing a boundary circle that encompasses only the sheep's body. Increase the Brightness slider to +20% and the Structure slider to 75%.

8. Place a fifth control point (5) in the shadow region near the sheep's eyes by zooming in and using the Loupe view to help you pinpoint the area. Then draw a relatively small boundary circle around the sheep's head and increase the Shadow adjustment to +50% (**FIGURE 2.20**).

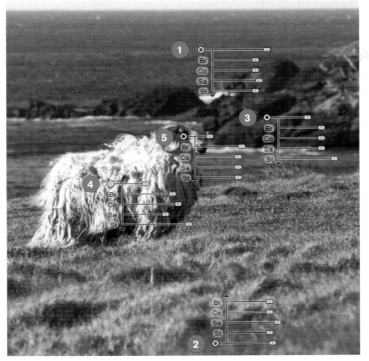

FIGURE 2.19
It's not uncommon to use several control points to create your desired look.

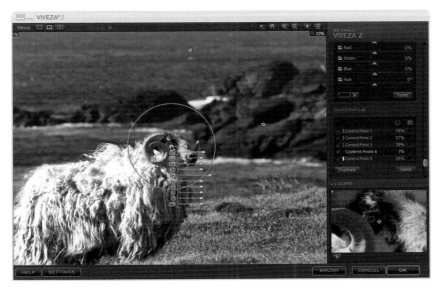

FIGURE 2.20 When you're zoomed in, the Loupe view can be very helpful in placing control points.

9. For a before and after view, go to the Side-by-Side Preview to see the adjustments you've made to this image (**FIGURE 2.21**). You've made vast improvements from where you started.

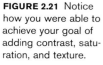

FIGURE 2.21 Notice how you were able to achieve your goal of adding contrast, saturation, and texture.

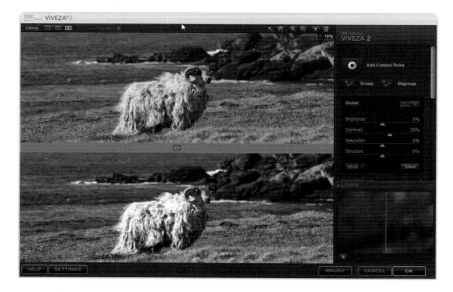

Enhancing a Portrait

As with a landscape, the key to creating a nice portrait is taking the extra time in processing and highlighting a person's unique features while correcting problems with the portrait. Once again Viveza comes to the rescue! The image in **FIGURE 2.22** is a last-minute headshot I took for my sister for her yoga business. Let's correct a few of my mistakes and add a couple of enhancements.

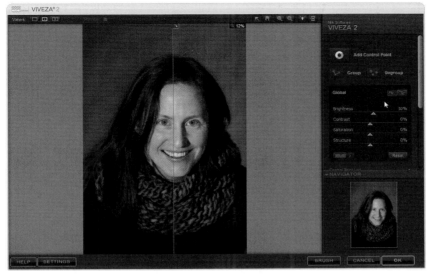

FIGURE 2.22 Assess your image and take note of the goals you want to achieve during processing.

I'll attack this image edit the same way I did for the landscape by identifying elements I want to improve and setting some goals:

- Brighten the image just a bit (Global)
- Add color to her face (Control Point)
- Apply some skin-tone smoothing (Control Point)
- Highlight her beautiful blue eyes (Control Point)
- Whiten her teeth (Control Point)
- Make the portrait pop out of the frame by burning in the background (Control Point)

1. Let's start by making our only planned Global adjustment by increasing the Brightness slider to +10% to adjust for the dark exposure (**FIGURE 2.23**).

2. Next, I'll use Control Points to improve this image and make my little sister happy. The first control point (1) (**FIGURE 2.24**) I add isolates the background and makes it a tad darker when I move the Shadow slider to -25%. The Shadow slider works strictly on the dark regions of the image while avoiding darkening the entire image.

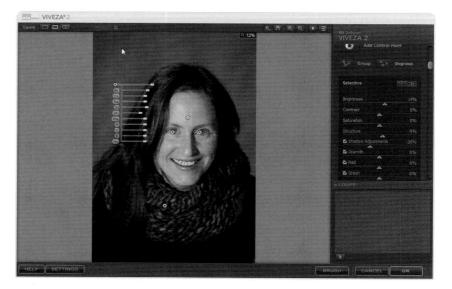

FIGURE 2.23 Always make Global adjustments first before making Selective adjustments.

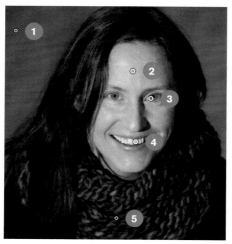

FIGURE 2.24 Group similar control points to help in managing workflow.

3. I place the second control point (2) on her forehead, zoom in, and draw a boundary circle that encompasses only her face. I soften her skin by reducing the Structure slider by -20%. Be careful not to overdo it, or the face in the image will be unnatural and plastic looking. I then add a little color in her face by moving the Warmth slider to +10.

4. I place the third control point (3) on her iris while using the Loupe view to help navigate. Once placed, be sure to reduce the boundary circle to include only the eye. I then increase the Saturation slider to +30% and

add a little sharpness to the fine details by increasing the Structure slider to +20%.

5. By duplicating the third control point by pressing Ctrl+D (Command+D) and placing it on the other eye, I create a fourth control point. I know, it's easy! This is an excellent place to group the control points because they are performing an identical function.

6. I place the fourth control point (4) on her teeth and create a very small boundary circle that encompasses only her teeth. I lighten her teeth a bit by increasing the Brightness slider to +20%. Although the slider did a pretty nice job, a few of her teeth aren't quite as bright as I'd like, so I create another control point.

7. I place a fifth control point on the areas of the teeth that still need to be whitened, but instead of using the Brightness slider again, I copy the color settings from the previous control point using the eyedropper technique outlined earlier in the chapter. This will ensure that the shades are consistent throughout, creating a natural look. Once again, this is a great opportunity to group the control points because they are performing identical functions.

8. I place a final control point (5) on her scarf and move the Shadow slider to -20% to burn in around her face, creating a natural frame around her face.

9. Finally, I review a Side-by-Side Preview of where I started and the final product (**FIGURE 2.25**). Notice that the image on the right is lighter, the skin is slightly softer, the teeth are whiter, and her blue eyes are vibrant.

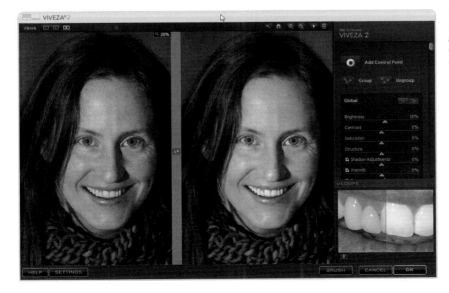

FIGURE 2.25 Natural-looking improvements are always the goal when you're working with portraits.

1. Take a moment to make a plan for your image. Outline a few goals for your editing to save time and realize your vision.

2. Always start with Global adjustments; don't immediately start placing control points. After you make your Global adjustments, take note of anything you'll need to fix with control points.

3. Remember that you can make Selective adjustments only if you've placed a control point on the image. Always check to see if you're making Global or Selective adjustments.

4. Smooth skin tones by using a control point and moving the Structure slider to the left.

5. After using Selective Color in Silver Efex Pro, import your image into Viveza and use Control Points to further adjust your Selective Color assignments.

6. Use Control Points and the Color Picker to add color to dull skies or a sunset reflection on water.

7. Group control points that perform an identical function.

8. Use Loupe view when you need an exact placement for a control point, such as on the iris of the eye.

9. Bring your subject into focus by darkening the background using Control Points.

10. Move the Warmth slider to the left to neutralize a yellow color cast.

Viveza Keyboard Shortcuts

	WINDOWS	MACINTOSH
INTERFACE		
Undo	Ctrl+Z	Command+Z
Redo	Ctrl+Y	Command+Y
Full Screen	F	F
Preview	Ctrl+P	Command+P
Show/Hide Control Palettes	Tab	Tab
Apply Filter	Enter	Return
Cancel Filter	Esc	Esc

	WINDOWS	MACINTOSH
CONTROL POINTS		
Add Control Point	Ctrl+Shift+A	Command+Shift+A
Delete Control Point	Delete	Delete
Duplicate Control Point	Ctrl+D	Command+D
	Alt-drag	Option-drag
	Ctrl+C (to copy)	Command+C (to copy)
	Ctrl+V (to paste)	Command+V (to paste)
Expand/Collapse Control Point	E	E
Group Control Points	Ctrl+G	Command+G
Ungroup Control Points	Ctrl+Shift+G	Command+Shift+G
TOOLS		
Select tool	A	A
	Ctrl (temp. switch to)	Command (temp. switch to)
Pan tool	H	H
	Spacebar (temp. switch to)	Spacebar (temp. switch to)
Zoom In tool	Z	Z
	Ctrl+spacebar (temp. switch to)	Command+spacebar (temp. switch to)
Zoom Out tool	Z	Z
	Ctrl+Alt+spacebar (temp. switch to)	Command+Option+spacebar (temp. switch to)
Zoom In	Ctrl+'+'	Command+'+'
Zoom Out	Ctrl+'−'	Command+'−'
Zoom to Fit	Ctrl+0	Command+0
Zoom to 100%	Ctrl+Alt+0	Command+Option+0

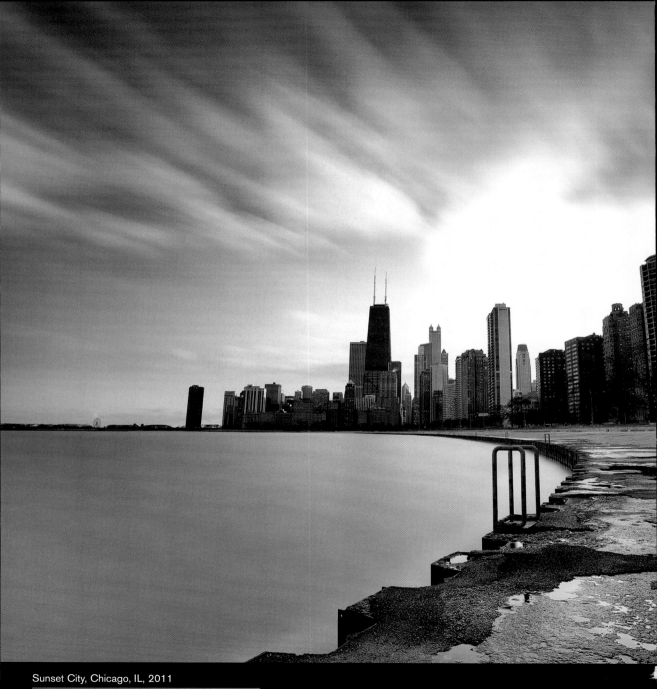

Sunset City, Chicago, IL, 2011

Canon 5D Mark II 16mm 71 @ f/16 ISO 125

3

COLOR EFEX PRO 4

The very first plugin I ever owned was Color Efex Pro (CEP), and to this day it's probably my second favorite, right behind Silver Efex Pro. The reason for my love affair with CEP is due in large part to its amazing library of unique filters and presets. CEP is the kitchen sink of plugins that allows me to focus on being creative without getting bogged down in all the technical ins and outs of how an effect is created.

In this chapter you'll explore how to use CEP to meet your creative goals while maintaining best practices for a great experience. With over 50 filters, it is impossible to cover them all, but I'll review some of the most popular as a well as a few of my favorites.

In the next few pages you'll get to know the interface, review how you can stack filters, and use the Opacity slider and control points to make precision adjustments. In the end you'll find that CEP is an amazing plugin that gives you the biggest bang for your buck, and it will prove to be an essential part of your workflow.

My Workflow

Color Efex Pro is like the Swiss Army knife of plugins and can be used at any point in your workflow (after noise reduction of course!). I use CEP much like I do Viveza—for addressing problems such as color cast and dull skies, and to create unique effects. But unlike Viveza, CEP offers numerous presets to help you visualize your creative options.

When I'm dealing with an image that requires just one or two filters, I'll export the image directly into CEP from my host program (such as Lightroom, Photoshop, or Aperture). However, if my image is more complicated and requires a litany of adjustments, I prefer to use Photoshop's Smart Objects because I can open the image in CEP repeatedly and make further edits as needed. I'll address this technique in Chapter 7, "Advanced Techniques in Photoshop."

The most important fact to remember about CEP is that you don't need to be a "Photoshop wizard" to use it. That doesn't mean this program is dumbed down by any means; it just means it has been designed to help you work smarter, not harder. When you're working in CEP, determine at the outset how you can make the plugin work for you. Do you need to fix a dull sky? Do you want to create a really cool, faded film look? These questions will help you organize your workflow. Most important, don't forget to have fun and allow CEP to bend your creative will, because it's through experimentation that you will grow as an artist.

Enough of the pep talk. Let's take a look at this plugin, and explore the interface and practical applications for its use.

The CEP Interface

In a nutshell, CEP is like an image processing cookbook with an instant gratification button built in. The left panel lists all of the different digital recipes (filters) and provides you with snapshots showing slight variations (presets) of those recipes (**FIGURE 3.1**). At any point in your workflow you can just click a recipe, and if you like what you see, simply call it good and click the Save button. Or you can take it a step further to create your own unique recipe by adding more filters and stacking unique effects on one another.

The right panel grants ultimate control over these filters via control points, enhancement sliders, opacity, and stacking. Your goal should be to become comfortable enough with this interface to know your way around the digital kitchen and create the best image possible! Now let's take a look at the interface in a bit more detail.

FIGURE 3.1 Creating unique images is easy with CEP's intuitive interface.

The Left Panel Adjustments

The left panel is composed of three essential parts that help you visualize and organize your workflow.

Filter Categories Selector

The Filter Categories Selector allows you to reduce the number of filters displayed within the Filterlist by selecting a category of interest, such as Landscape (**FIGURE 3.2**). Typically I use the same filters over and over, so I use the Favorites category to expedite my workflow. To add filters to the Favorites category, click the star to the left of your favorite filter.

Managing categories

Some of you will work predominately with one category of filters. To change your category sequence, click Settings to open the Settings dialog box. Navigate to Filterlist Settings and select which style of photography you want to place in each category location (**FIGURE 3.3**).

FIGURE 3.2 Use any of the more than 50 filters to help you visualize your final image.

FIGURE 3.3 Work more efficiently by organizing your filters by your style of photography.

The Filterlist displays all the filters found within a selected category. To navigate the list, click a filter and use the up and down arrows or your mouse's scroll wheel to move between filters.

Each filter has several presets available to help guide you in visualizing your postprocessing goal. To access a preset, select a filter and then click the Preset button (**FIGURE 3.4**) to reveal that filter's presets.

While you're in Preset view (**FIGURE 3.5**), you can click the up and down arrows at the top of the preset Preview window to scroll through all available presets in the Filterlist.

FIGURE 3.4 Click the Preset button to view all available presets.

Cooking with Recipes

One of the great aspects of using CEP is the ability to create recipes (unique presets) that you can use at a later date. These recipes allow you to apply the effects of a single filter or multiple filters to an image with one click. Recipes can be very helpful in speeding up your workflow and creating a consistent style. Although presets are listed in the left panel adjustments, this is a good time to briefly head over to the right panel to show you how to create one.

Creating a recipe

To create a recipe, make your desired adjustments to a filter or stack of filters and click Save Recipe (**FIGURE 3.6**). After you've named your new recipe, it will appear in the Custom Recipes category. By default, in recipes you're able to save filters, slider adjustments, and Opacity settings but are unable to save control point adjustments because control points are generally image specific.

FIGURE 3.5 Click any of the presets or review all category presets by using the up and down arrows.

FIGURE 3.6 Create your own recipes to speed up your work-flow and maintain a consistent style.

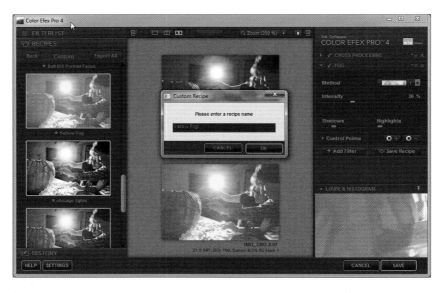

It's not possible to create your own categories; therefore it's best to mark your custom recipes as a favorite so that you have quick access to them in the Favorites category (**FIGURE 3.7**).

Managing recipes

To delete a recipe, hover your mouse over the recipe and click the X in the top-left corner. If you need to export a preset, click the arrow in the top-right corner. If you need to update a preset to match the current filters being applied, click the circle with arrows in the bottom-right corner. Keep in mind that when you update the presets, none of the control point information is saved (**FIGURE 3.8**).

FIGURE 3.7 Mark your favorite recipes so you can access them quickly.

FIGURE 3.8 Delete, export, or update your recipes as needed.

History Browser

The History browser is a chronological list of all the adjustments made to an image (**FIGURE 3.9**). It's a wonderful tool when you need to step back in time but don't want to undo everything you've created. I like to use the History browser to compare different stages (states) in my edits. By default, the History State Selector is positioned on your original image so that you are always comparing all edited states to the original image. You can move this selector down to any state along your edit timeline. Using the History State Selector, you can compare your current setting to any stage along the editing process and view those comparisons using Split Screen Preview, Side-by-Side Preview, or Single Image Preview when you click the Compare button.

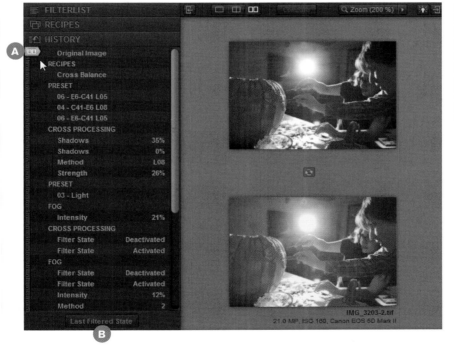

FIGURE 3.9
Use the History State Selector (A) to compare edits. Click the Last Filtered State button (B) to process your image using the same settings used on your last image.

The Last Filtered State button at the bottom of the History browser works much like a preset but instead processes your image using the exact filters, control points, and Opacity settings used on your last image. This tool is very helpful when you need to process an image using the same control points. Remember that presets *do not* remember your control points by default, so this is a great alternative when you need to batch edit images (such as headshots).

BACK TO THE FUTURE WARNING

The History browser is different than an Undo button in that if you decide to go back in time and make edits to a previous state, any edits that you've made from that point on will be wiped out. That's right: You can change the past, but it will change the future!

Top Menu

Control how you view an image by using the basic controls at the top of the interface. Let's review these basic features starting from left to right (**FIGURE 3.10**).

FIGURE 3.10 Adjust these settings to optimize your workspace.

A Panel Display Selector
B Single Image Preview
C Split Screen Preview
D Side-by-Side Preview
E Compare button
F Zoom tool
G Background Color Selector

Adjustment panel hide/show

Show or hide either the left or right panel by selecting the Panel Display Selector, or press the Tab key to toggle between opening and closing both adjustment panels at once.

Image Preview modes

Use Single Image Preview to view the entire image, or use Split Screen Preview and Side-by-Side Preview to compare before and after results.

Compare button

The Compare button allows you to toggle between the newly edited image and state selected by the History State Selector. Keep in mind that the Compare button works only in Single Image Preview mode.

Zoom tool

The Zoom tool is great for reviewing images and identifying potential problems, such as dust, noise, or halos. To activate this tool, click the magnifying glass or press the spacebar and the Navigator window will appear, enabling you to pan around the image.

Background Color Selector

Use the Background Color Selector to adjust your screen's background to gray, black, or white. I prefer to use the default gray while I'm in CEP to maintain a neutral background, but you can set this according to your preference.

The Right Panel Adjustments

If the left panel is like a cookbook that helps you visualize and organize your recipes, the right panel is definitely the kitchen where you can make your own creations, either by starting with a recipe (preset) or going solo and creating your own looks and effects. It's in this panel that you can add filters and make global and selective adjustments. Frankly, this is where all the fun takes place. Once you get the hang of these settings and how they work, you'll be making killer images in no time. Let's explore how to add filters and make adjustments.

Adding filters

Before you begin manipulating an image, first select one or more filters from the Filterlist. Once selected, these filters will appear in the right panel (**FIGURE 3.11**). Each filter has its own set of enhancement sliders, even though many of them share similar functions.

By default your image will appear with a preview of a filter's effect. To hide or show the effect of the filter on your image, select or deselect the Toggle Filter box. This tool can be very helpful when you're stacking several filters on top of one another and you want to preview your image with a particular filter turned off.

Filter Control menu

The Filter Control menu is located directly to the right of the filter's name and is somewhat hidden. Once you find it, you'll realize that this is a feature-rich tool that you can use when you're working with multiple filters and control points (**FIGURE 3.12**).

FIGURE 3.11 Expand stacked filters by selecting the expansion triangle to the left of the filter's name.

FIGURE 3.12 Copy and paste control points from the Filter Control menu.

The menu contains the following four items:

- **Copy Control Points.** Use this feature to copy all the control points to a clipboard so you can paste them into another filter. This is helpful when you need to maintain the same control point selections from one filter to the next. The keyboard shortcut is Ctrl+C (Command+C).

- **Paste Control Points.** Use this feature to paste the previously copied control points to the current filter. The keyboard shortcut is Ctrl+V (Command+V).

- **Reset Filter (keep CPs).** Use this feature to reset the filter to its default value while maintaining your control point selections.

- **Reset Filter (delete CPs).** Use this feature to reset the filter and delete the control points.

Delete a filter

To delete a filter, click the X immediately to the right of the Filter Control menu.

Stacking filters

This is important! If you plan on stacking filters, you'll need to click the Add Filter button. Otherwise, if you skip this step and click another filter in the Filterlist, CEP will simply replace your current filter with newly selected one. Ouch! Avoid frustration and remember this handy shortcut: To avoid clicking the Add Filter button, hold down the Shift key when you're adding another filter, and CEP will stack the filters accordingly.

Shadow and Highlight recovery

The Shadow and Highlight sliders (**FIGURE 3.13**) bring details back into the shadow and highlight areas of your image. Not every filter will have this feature, but if it's available, move the sliders to the right to help recover lost detail. I recommend using the Clipped Highlights and Shadows feature, which you can activate by rolling your mouse over the Loupe view. Select the Show Clipped Highlights and Shadow check boxes; highlights lacking detail will appear in green and shadows lacking detail will appear in red.

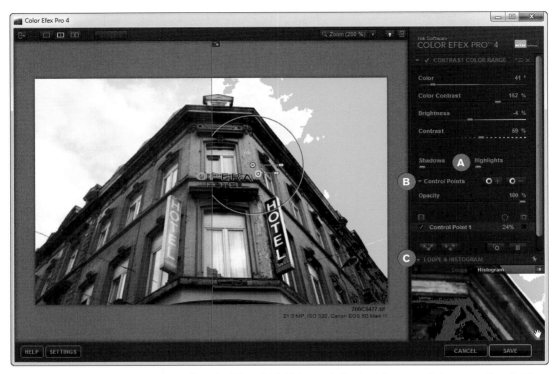

FIGURE 3.13 Use the Clipped Highlights and Shadows feature to help recover lost details.

A Highlights and Shadows sliders
B Positive and Negative Control Points
C Loupe view

Control points

You can make selective adjustments by placing control points anywhere on your image.

A Positive Control Point adds the filter's effect to the selected area. It does this by setting Opacity to 0%, so only the area on which you place the control point will receive 100% of the filter's effect.

A Negative Control Point removes the filter's effect from a selected area. It does this by setting the Opacity to 100% and removing the filter's effect in regions that you've placed Negative Control Points.

Opacity slider

Use the Opacity slider to control the overall opacity of the selected filter. To increase the visibility of the filter's effect, move the slider to the right. To decrease the visibility of the filter's effect, move the slider to the left.

Organizing control points

From left to right in **FIGURE 3.14**, use these buttons to organize your control points:

- To group control points, click the Group button, or press the Shift key while selecting the control points you want to group and then press Ctrl+G (Command+G).

- To ungroup control points, select your master control points and click the Ungroup button or press Ctrl+Shift+G (Command+Shift+G).

- To duplicate a control point, select the control point you want to duplicate and click the Duplicate button or press Ctrl+D (Command+D).

- To delete a control point, select the control point and click the trash can or press the Delete key.

FIGURE 3.14 Four buttons help you organize your control points.

My Top Ten Favorite Presets

CEP has over 55 presets preloaded and an increasing number of presets online at niksoftware.com/presets as well other websites. Each photographer will definitely have a favorite filter, or if you're like me, you'll have a love affair with a particular look and filter effect. The following ten filters are some of the most popular with a few of my favorites.

Black and White Filter

The very first black-and-white filter I ever used was CEP B/W Conversion. In the past few years I've done most of my black-and-white work in Silver Efex Pro, but on occasion I still gravitate back to my first love. The B/W Conversion filter (**FIGURE 3.15**) offers five presets to choose from and gives you precise control over shadows and highlights, as well as three black-and-white conversion methods: B/W Conversion, Tonal Enhancer, and Dynamic Contrast. I'll focus primarily on the B/W Conversion and Dynamic Contrast methods and their four main conversion sliders. The B/W Conversion method is the most universal and the one you should experiment with first. The Dynamic Contrast method and Tonal Enhancer are more stylized and will give a different feel to your image.

FIGURE 3.15 Here I used the Dynamic Contrast method filter to convert my color image to black and white with style.

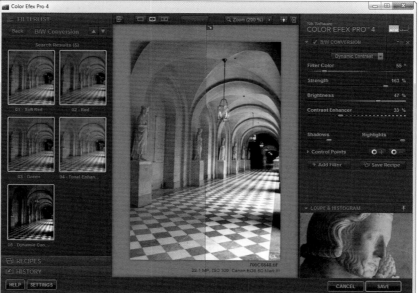

- **Filter Color slider.** Use this slider to simulate black-and-white color filters. Adjust the slider to the color you want to lighten and the complementary color will be darkened. For instance, a yellow filter will lighten anything that is yellow while darkening blues and greens.

- **Strength slider.** Use this slider to control the overall contrast between colors. Move the slider to the left to decrease contrast between colors and to the right to increase contrast between colors.

- **Brightness slider.** Use this slider to control the overall exposure of the image. Moving this slider will affect your entire histogram, making the image overall lighter or darker.

- **Contrast slider/Contrast Enhancement slider.** Use these sliders (depending on your chosen method) to control the overall contrast in an image. Move the slider to the right to increase contrast and to the left to decrease contrast.

Application

Although the B/W Conversion filter is very effective for making basic black-and-white adjustments, it's still a bit limited compared to the power of Silver Efex Pro 2. With that said, if I'm dealing with an image that has well defined shadows and good contrast, I often use the Dynamic Contrast method and its unique Contrast Enhancer slider. As shown in Figure 3.15, this method does a great job of handling the tonality and creating a very natural and clean black-and-white image.

Brilliance/Warmth Filter

If I weren't such a black-and-white nut, I probably would have listed the Brilliance/Warmth filter first. Although it is such a simple filter, it is incredibly important for improving many of my images. The Brilliance/Warmth filter (**FIGURE 3.16**) is great for enhancing portraits and landscape images.

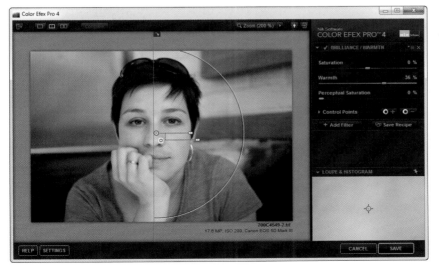

FIGURE 3.16 Use the Brilliance/Warmth filter to warm up skin tones.

This filter offers three basic sliders to affect saturation and warmth in your images:

- **Saturation slider.** Increase saturation by moving the Saturation slider to the right and decrease saturation by moving it to the left. I recommend using this slider carefully to avoid oversaturating your images and creating a cartoon effect (unless that's what you're going for—I'm *not* judging!).

- **Warmth slider.** The Warmth slider controls the overall temperature of your image. A cool image will have more blue in it, and a warm image will have more red in it. Move this slider to the right to warm up an image or to the left to cool down an image. This is the slider I use the most and often is the only slider I use in this filter.

- **Perceptual Saturation slider.** The Perceptual Saturation slider works by altering the hues of the colors to increase the perception of the saturation of those colors. This is achieved by increasing complementary color saturation in surrounding colors, thus creating perceptual saturation. I rarely use this slider because it creates some bizarre-looking images. But every once in a while it surprises me.

Portrait application

Let's walk through an example to apply the Brilliance/Warmth filter to a portrait. To warm up the image in Figure 3.16 just a tad, let's use the Warmth Slider with a Positive Control Point.

You start by increasing the overall warmth of an image using the Warmth slider to warm up the flesh tones. Next, drop a Positive Control Point on the person's face while drawing a relatively small boundary circle. This will apply the effect directly to the skin tones without warming up the entire image. You can use the control point's Opacity slider to further tweak the amount of
the filters.

Landscape application

To give my images the feeling that they were shot in the evening, I'll often cool them down using the Brilliance/Warmth filter (**FIGURE 3.17**). In this example I decreased the Warmth slider by -76%, and to add a little warmth back to the rocks I increased the Perceptual Saturation slider. In this case the Perceptual Saturation helped to highlight the color detail in the rocks. As mentioned earlier, Perceptual Saturation occasionally surprises me.

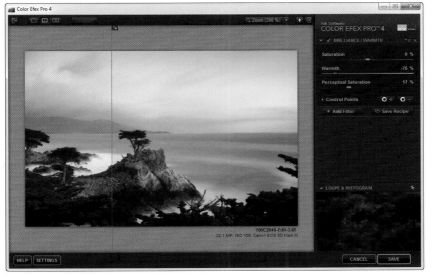

FIGURE 3.17 Cooling off an image can create a moody effect.

Bleach Bypass Filter

Use the Bleach Bypass filter when you want to create a very high-contrast image with low color saturation resulting in a very stylized effect (**FIGURE 3.18**). This technique simulates traditional film that is processed without bleaching, which would leave silver in the emulation with the dyes, resulting in increased contrast, reduction in saturation, and an increase in graininess. This filter offers four sliders to control the brightness, saturation, and contrast in an image.

- **Brightness.** Use this slider to control the overall exposure of the image.

- **Saturation.** Use this slider to control the overall vibrancy of the colors. Move the slider to the right to increase overall vibrancy and to the left to decrease overall vibrancy.

- **Contrast.** Use this slider to control the overall contrast (difference between light and dark) of an image. To increase contrast move the slider to the right, and to decrease contrast move the slider to the left.

- **Local Contrast.** Use this slider to increase small details and textures in an image.

FIGURE 3.18 Use the Bleach Bypass filter to dramatically increase contrast and details.

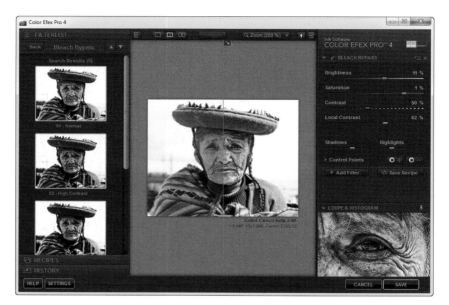

Application

I love working with this filter when I'm dealing with a portrait or an image that has a lot of texture and character. Often I bring an image into the Bleach Bypass filter to get a very stylized look, and then import the image into Silver Efex Pro 2 to finish the black-and-white processing. This gives certain black-and-white images a very distinctive look and feel.

Classic Soft Focus Filter

When you want to add a subtle soft focus or vignette to direct your viewer's eye, the Classic Soft Focus filter is for you (**FIGURE 3.19**). This filter does a great job of mimicking soft-focus filters and diffusion techniques. Typically, I use this filter to help steer a viewer's eye to a center focal point. You could use the Vignette: Blur filter as well, but I find the Classic Soft Focus filter to be a little less obvious and easier on the eyes.

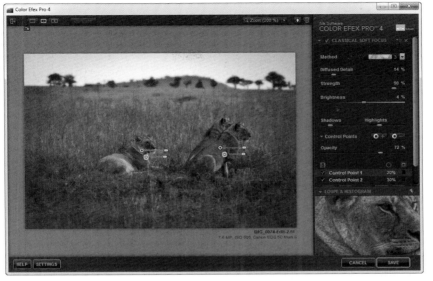

FIGURE 3.19 The Classic Soft Focus filter helps to create a natural-looking vignette.

The options and sliders in this filter include:

- **Method.** Use the Method drop-down menu to access three unique Soft Focus and Diffusion effects (**FIGURE 3.20**). As you experiment with the list of methods, you'll notice that brightness and contrast are noticeably different from any of the Soft Focus 1 to 3 or Diffusion 1 to 3 presets.

- **Diffused Detail.** Use the Diffused Detail slider to increase or decrease the appearance of random detail in your image while avoiding banding. I recommend using this slider judicially because it can introduce unwanted noise to your image.

- **Strength.** Use this slider to control the amount of softening or blur that is added to your image.

- **Brightness.** Use this slider to control the overall lightness of your image.

FIGURE 3.20 Change the look of the soft focus by using any of the six presets.

Application

In the image of the lion pack in Figure 3.19, I used the Diffusion Method 3 and placed two Negative Control Points on the lions to maintain their focus while slightly blurring the surroundings.

Detail Extractor Filter

The Detail Extractor filter should really be called the HDR Light filter because it does such a great job of mimicking an HDR image without all the fancy footwork (**FIGURE 3.21**).

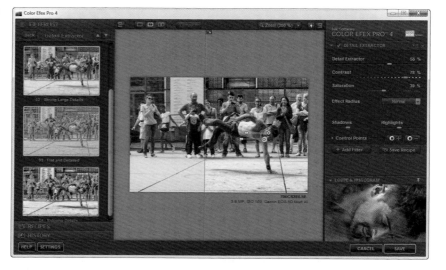

This filter creates a very stylized image by extracting details throughout your entire image. Its sliders and options include:

- **Detail Extractor.** Use this slider to lighten shadows and darken highlights while adding detail throughout your image.

- **Contrast.** Use this slider to control the overall contrast (difference between light and dark) of an image. To increase contrast move the slider to the right, and to decrease contrast move the slider to the left.

- **Saturation.** Use this slider to control the overall vibrancy of the colors. Move the slider to the right to increase overall vibrancy and to the left to decrease overall vibrancy.

- **Effect Radius.** Use this drop-down menu to select which size object the Detail Extract filter will concentrate on (**FIGURE 3.22**). Use Fine radius for smaller objects where you want to create obvious texture, such as in wood, cement, brick, flower petals,

FIGURE 3.22 Often Normal radius does a great job of creating a more natural-looking image.

and so on. Use Large radius to concentrate on larger objects while reducing the accentuation of smaller details. The Normal radius setting does a great job of finding a good balance between the detail and contrast within the image.

Application

The Detail Extract filter did a great job of allowing me to highlight the dancer's chiseled physique as well as his surroundings in Figure 3.21. I placed a control point on his head and reduced the Opacity to allow for a more natural appearance.

Glamour Glow Filter

The Glamour Glow filter is a portrait and wedding photographer's go-to filter because it creates a very angelic effect (**FIGURE 3.23**).

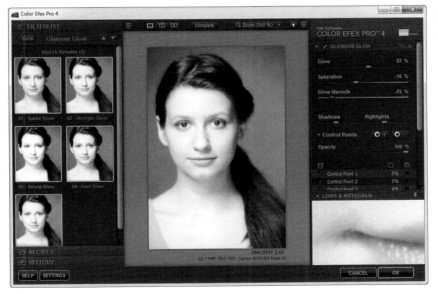

FIGURE 3.23 Use the Glamour Glow filter to create a soft glow.

What I like about this filter is that it combines the Glow effect with the Glow Warmth slider, which works similarly to the Brilliance/Warmth slider. The Glamour Glow filter sliders include:

- **Glow.** Use this slider to control the overall softness of your image.

- **Saturation.** Use this slider to control vibrancy of the colors in your image.

- **Glow Warmth.** Use this slider to control the temperature of the image. Move the slider to the left to cool the image and to the right to warm the image.

Application

I use the Glamour Glow filter primarily when I'm working with portraits and want to add a soft yet smoothing effect. In the image in Figure 3.23 I wanted to cool down the background while maintaining a nice glow on the subject. I placed several Negative Control Points on her face while manipulating the control points' Opacity sliders to allow for some transparency. This allowed me to maintain most of the original skin tone colors while applying the glow and cooling down the background.

Graduated Neutral Density

The Graduated Neutral Density filter is a landscape photographer's best friend because it allows you to darken or lighten areas of an image that weren't properly exposed during capture (**FIGURE 3.24**). Typically this occurs when you have a bright sky but a very dark foreground. You might be wondering why you would use this tool and not just make these adjustments in your host program. Several of the filters in CEP can be mimicked in another host program, but the level of control and ability to make quick selective adjustments via control points trump other host applications (that's not to say it can't be done, but in my opinion not nearly as efficiently).

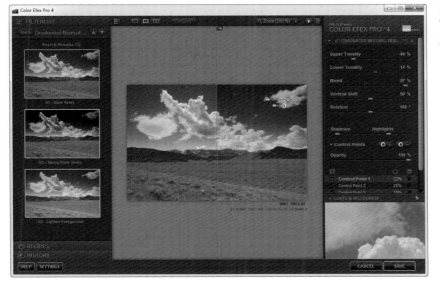

FIGURE 3.24 Use the Graduated Neutral Density filter to correct for mixed exposures.

The Graduated Neutral Density filter sliders include:

- **Upper Tonality.** User this slider to control the brightness at the top of the image.

- **Lower Tonality.** Use this slider to control the brightness at the bottom of the image.

- **Blend.** Use this slider to control the size of the blend between the original image and the filter effect.

- **Vertical Shift.** Use this slider to control the placement of the filter's horizon. Moving the slider to the right increases the size of the area being covered by the filter.

- **Rotation.** Use this slider to control the angle of the filter's horizon. This can be effective if you want to shape the direction or appearance of sunlight.

- **Shadows and Highlights.** Use this slider to recover lost detail in the shadow and highlight regions of your image.

Application

The Graduated Neutral Density filter simulates the effects of a lens-mounted graduated neutral density (ND) filter. Frankly this filter works so well that there are times I wonder if I need my ND filter at all! In the image in Figure 3.24 I started with the Dark Skies preset and made adjustments to the Tonality sliders. But I wanted the clouds to be as bright as possible, so I placed a Negative Control Point on the clouds and adjusted the Opacity slider to allow some transparency.

> **HOT TIP**
>
> Often clouds lose details in the highlights, so use the Highlight slider to help recover those lost details and add dimension to your clouds.

Image Borders

Image Borders is a new feature in Color Efex Pro 4, and it's a welcome addition. This filter applies unique and very organic-looking borders to your images (**FIGURE 3.25**).

FIGURE 3.25 Create unique, organic-looking borders.

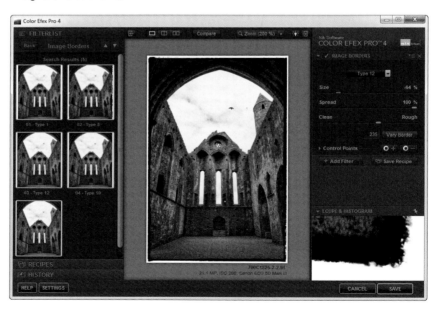

The Image Borders filter offers the following sliders and options:

- **Size.** Use this slider to control the size of the border being created. To increase the border move the slider to the right, and to decrease the border, move the slider to the left. Keep in mind that as you increase the size of the white border, it will reduce the viewing area of your image.

- **Spread.** Use this slider to control the size of the black border edge being created. Once again, moving the slider to the right decreases the viewable area of your image.

- **Clean/Rough.** Use this slider to add details randomly to the border edges. Moving the slider to the left creates more of a straight edge, whereas moving the slider to the right generates a very organic or hand-made paper effect.

- **Vary Border.** The Vary Border button randomly selects a different border seed number to generate a unique-looking border. To create an exact duplicate of a border, you need to know the border type number, Size, Spread, Clean/Rough, and seed number. It's a lot to know, so read my hot tip for a quick suggestion on streamlining this process.

HOT TIP

To create the same border, I recommend creating a preset for your favorite border(s). To create a similar but distinctive border, use your preset and simply type in a new seed number ranging from 0–9999.

Application

Nik has created some very cool borders that really enhance an image's appearance. My only complaint is that whenever you adjust the size and spread of a border, it results in the loss of image area. To negate this problem, my recommendation is to use Photoshop whenever possible to create a larger canvas size and apply the new border to that without encroaching on the image area. You can see an example in the "Adding Borders" section in Chapter 7.

Film Efex

There seems to be a resurgence of images simulating the look and feel of the 1960s and 1970s, so I was happy to see that Nik added several new film filters to Color Efex Pro 4. This comprehensive list of film-simulating filters includes Faded, Modern, Nostalgic, and my personal favorite, Vintage (**FIGURE 3.26**). These four Film Efex filters do a great job of making your digital image appear as though it was authentically created using film.

FIGURE 3.26 Use the Film Efex filters to transform a digital image into an authentic-looking, film-processed image.

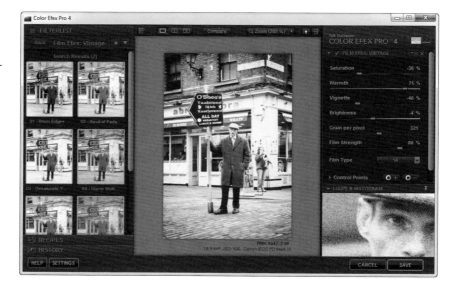

Use the following sliders and options to adjust these effects:

- **Saturation.** Use this slider to control the overall vibrancy of the colors. Move the slider to the right to increase overall vibrancy and to the left to decrease overall vibrancy.

- **Warmth.** Use this slider to control the temperature of the image. Move the slider to the left to cool the image and to the right to warm the image.

- **Vignette.** Use this slider to create a classic circular vignette. Move the slider to the left to darken the edges and to the right to lighten the edges.

- **Brightness.** Use this slider to control the overall lightness of your image.

- **Grain Per Pixel.** Use this slider to add the appearance of grain to your image. Move the slider to right to decrease the appearance of grain or to the left to increase the appearance of grain.

- **Film Strength.** Use this slider to increase or decrease the strength of the selected film type. Move the slider to the right to increase the strength of the film type, or move the slider to the left to decrease the strength of the filter. A Film Strength of zero will reveal the original color of your image.

- **Film Type.** Use this drop-down menu to select from 29 presets of unique combinations.

Application

The Film Efex filters are great filters to use when you have an image that already lends itself to a timeless feel. In the image in Figure 3.26, which was taken in Ireland, I used the Desaturation Yellow preset and then made adjustments from there that included a stronger vignette and an increase in the size of the film grain.

Reflector Efex

Have you ever been on a shoot and wished you had a gold/silver reflector with you? The Reflector Efex filter will help eliminate that worry by allowing you to create a gentle gold, soft gold, or silver reflector effect (**FIGURE 3.27**).

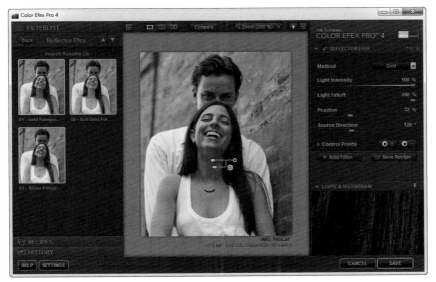

FIGURE 3.27 Use this filter when you need a little help filling in shadows with a gold/silver light.

You can adjust the following options and sliders to create the desired effect:

- **Method.** Choose Gold, Soft Gold, or Silver from the drop-down menu. Gold warms the shadow regions of an image, Soft Gold adds a slight warming effect to those regions, and Silver adds a neutral light effect to the shadow regions of an image.

- **Light Intensity.** Use this slider to control the volume of light added to the image via the reflector.

- **Light Falloff.** Use this slider to control how quickly the filter's light fades.

- **Position.** Use this slider to control where the falloff begins.

- **Source Direction.** Use this slider to control the direction of the light source.

Application

The Reflector Efex filter is an ideal tool to use for when you need to fill in some shadows with a gentle bounce of light. In the image of the couple in Figure 3.27, I used the Source Direction slider to enhance the already obvious direction of the sun and chose Gold Method to add a nice gold light to the shadows on their faces.

From Start to Finish

To show you how I like to stack filters for a creative effect, I'll demonstrate the use of some of my favorite filters and effects from start to finish. **FIGURE 3.28** shows a before-and-after preview of a gentleman in Ireland playing an old Castrol-oil-can guitar. I thought it would be fun to create a postcard-looking shot using CEP. You can follow along with each step by registering your book at peachpit.com/nikplugin and downloading the image Street Guitar.tif.

1. Open Street Guitar.tif in CEP 4.0 and select the Photo Stylizer filter effect from the Filterlist. This effect does a great job of creating a very distinctive-looking image, and the Varitone effect is another of my favorites (**FIGURE 3.29**). Select the Varitone preset with the Number 1 style to bring out the reds and blues in this image. Increase the strength of the filter to 80%, and then recover some of the lost highlight detail using the Highlight slider.

2. Select Vignette: Blur from the Filterlist to apply a blur vignette (**FIGURE 3.30**). I want this blur to be fairly obvious in mimicking the Instagram look. Using the Shape Selector, choose a Circle blur because the subject is in the center of the frame. Select the Type 1 preset with a 100% Transition to create a nice smooth blur. To adjust the size of the blur so that it outlines the subject, move the Size slider to 22%. Then adjust the Opacity slider to 60%.

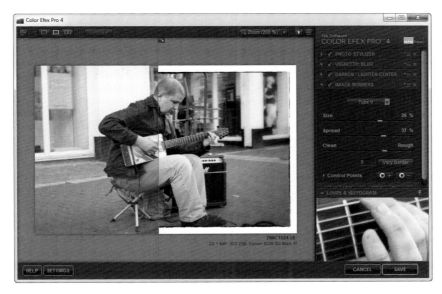

FIGURE 3.28 Stacking filters gives you the flexibility to create interesting effects.

FIGURE 3.29 Using the Varitone effect, you're able to accentuate the reds and blues in the image.

FIGURE 3.30 Frame your subject with a blur vignette to direct viewers' attention.

3. The Darken/Lighten Center filter is the perfect tool to use when you want to create a spotlight effect while darkening the borders of the image (**FIGURE** 3.31). Once again, similar to the blur selection, use the Circle-shaped preset 1. Next, increase the Center Luminosity slider to 50% while decreasing the Border Luminosity slider to -100%. Then use a Center Size of 60%.

FIGURE 3.31 Use the Darken/Lighten Center filter to help draw the focus to the center of an image.

4. Image Borders are a great way to finish off a photo (**FIGURE 3.32**). It's a matter of personal preference, but for this example I chose a Type 9 border with a Size of 30% and a Spread of 40%, and moved the Clean/Rough slider to the right to create a rough border effect.

Keep in mind that as you stack these filters you can toggle them on and off to review the effects. In many cases I go back several steps to a previously used filter and make adjustments.

FIGURE 3.32 The border is always the last element I add to my image.

As you can see from the preceding example, CEP is not only flexible, but also fun to use (**FIGURE 3.33**). People often ask me, "Why would I want to use Color Efex Pro, or any plugin for that matter, when I can do these things in Photoshop?" My response is always same. Go ahead and use what you love. But when it comes to ease of workflow, unique effects, and creative intuitiveness, I'll stick with what I love—Color Efex Pro! Remember that photography should be fun, so spend the time fixing your overexposed skies or flat images, but also make sure you make time to experiment and grow creatively.

As an extra bonus, register your book and go to www.peachpit.com/nikplugin to download a few of my favorite homegrown recipes.

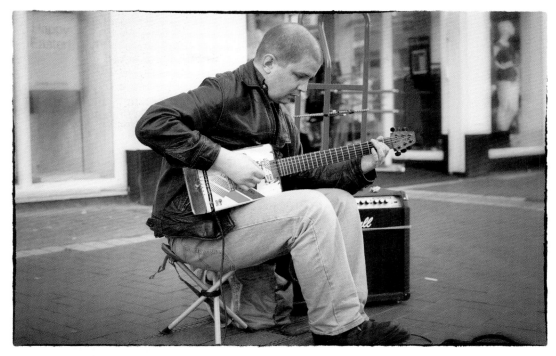

FIGURE 3.33 Stacking filters can help in creating a unique image or style.

Mesquite Flat Sand Dunes, Death Valley, 2011

SILVER EFEX PRO 2

Very few plugins have met with as much success as Silver Efex Pro 2 (SEP) and for good reason: It's simply the best and most essential black-and-white plugin on the market. Photographing a good image is difficult enough, so when it comes to processing, plugins that help you bring your vision to life effortlessly are indispensable. SEP does a great job of blending superior technology with ease of use. Frankly, I wouldn't have been able to make many of my favorite black-and-white images without this software!

In this chapter I'll explain my approach to using SEP while orienting you to SEP's interface and rich set of creative tools. Of course, you'll do this by creating images and exploring all the creative possibilities SEP has to offer.

Why I Use Silver Efex Pro

Black-and-white photography is experiencing a major resurgence despite film's ill-fated future. Although this may bristle the hairs on the backs of a few of you holding on tightly to your last roll of Tri-X, the reality is that the digital era is here to stay. You can think of SEP as a digital darkroom; its sole purpose is to help you create dynamic black-and-white images.

Why use SEP and not some other plugins or a software suite? Simply put, SEP does a better job because of its unique algorithm, which is designed to render a superior tonal range with exceptional contrast and texture control features. Its U-point technology allows you to make both global and very selective adjustments, depending on your visual direction, and its easy-to-navigate interface makes doing all of this fun! As photographers, you should own software that makes your life easier and that helps your visions come to life. SEP does just that.

Managing Your Files

Using SEP can be as straightforward as importing an image, applying a preset, and calling it good. Or, the process can be as complicated as creating several layers in Adobe Photoshop and mixing and matching different plugins to create your desired look. Regardless of the approach, all of my images start out in Adobe Lightroom before they are exported either into Photoshop or directly into SEP.

Proper image management is crucial to creating a seamless workflow, so I recommend using a program like Adobe Lightroom or Apple Aperture to manage your image library.

Two Approaches to Using SEP

When I first started using SEP, I exported the images directly into SEP, made the desired adjustments, and then saved the images back into my Lightroom library. This is still a great approach for black-and-white conversions, and if you're new to the plugin, I recommend this is where you start (**FIGURE 4.1**).

FIGURE 4.1 Exporting from a host program like Lightroom.

However, for those of you who use SEP in conjunction with Photoshop, you will benefit from the additional flexibility of being able to brush on certain effects (I'll show you how in Chapter 7), adjust blending and opacity, add layers—the list goes on. All of this flexibility comes at the cost of additional software and larger files but is well worth it when you're trying to create your unique vision.

Analyzing Your Image

Every time I import a new image into SEP I get a little giddy, simply because it feels like I'm an artist staring at a canvas. But instead of a blank canvas, it has a grayscale sketch of my image. The trick is to learn to use the tools in SEP to bring that sketch to life by dodging, burning, using the color filters, or choosing one of the many presets. Of course, understanding how to apply or when to apply these tools is part of the learning curve. By the end of this chapter, you'll be analyzing and creating wonderful black-and-white images.

When you import an image into SEP, first you want to examine it carefully without any distractions, so it's best to always start off in Single Image Preview. Once you have your image in front of you sans any distractions, you can take a three-part approach to evaluating it (**FIGURE 4.2**).

FIGURE 4.2 Use Single
Image Preview to ana-
lyze your image.

1. Identify the compositional components that make the image unique. It will be your job to highlight those components based on their characteristics and determine whether they require you to dodge, burn, amplify the texture, and so on.

2. Evaluate the tonal quality of the image. Begin by looking at the image and comparing it to the histogram. Is the image relatively flat with mostly midtones (**FIGURE 4.3**), or does it have a lot of contrast? Is it dark (low key) with the histogram pushed to the left (**FIGURE 4.4**), or is it light (high key) with the histogram pushed to the right (**FIGURE 4.5**)?

FIGURE 4.3 This histogram shows a lot of midtones with some contrast.

FIGURE 4.4 Notice how the histogram is pushed to the left in zones 0–3.

FIGURE 4.5 Notice how the histogram is pushed to the right in zones 7–9.

THE ZONE SYSTEM

You may have heard of The Zone System created by Ansel Adams and Fred Archer. The Zone System is an exposure technique that segments an image into 11 equal tonal graduations. Zero represents pure black (shadows), 5 represents middle gray (midtones), and 10 represents the pure white (highlights).

3. Envision how the image will look when you're done. Or, determine if you are at a loss for where to take it and need one of the many presets (**FIGURE 4.6**) to help guide your direction.

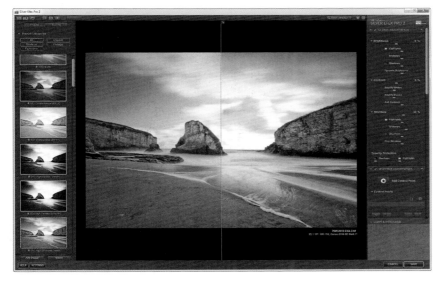

FIGURE 4.6 If you need help finding a creative path, start with a preset.

You're probably thinking that I spend a lot of time talking to myself; well, I won't deny it! But following the simple steps that I just outlined will help steer your process so you won't click presets aimlessly and move your sliders around until the image "just looks right." Although there's nothing necessarily wrong with that approach, it's not the most efficient or consistent way to produce a great image.

Setting Up Your Editing Workspace

Immediately after you've finished analyzing your image (**FIGURE 4.7**), one of the decisions you should make is whether or not you'll need to review the original color image during processing. By default, SEP displays only the grayscale conversion of the original image (**FIGURE 4.8**), so if you need to review the original color image, you need to change a few settings before beginning.

You might be wondering why you would need to review the color image. Well, you might use Selective Color to bring some color back into the image; in that case you'll definitely benefit from reviewing the original color image. In the image of a woman carrying groceries during a snowstorm in **FIGURE 4.9**, you'll notice a lot of yellow in the original. So I was able to brighten the image simply by using the yellow color slider, which has a very unique and different effect than if I had just used the Brightness slider.

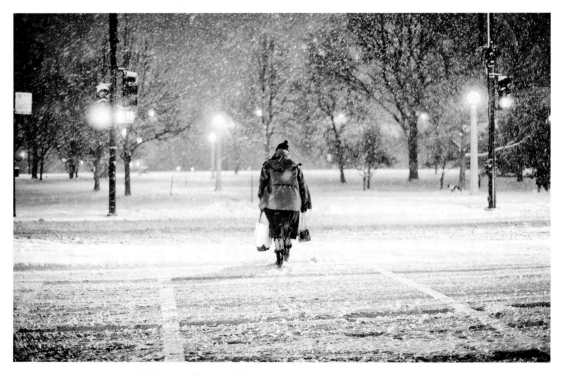

FIGURE 4.7 Chicago, 2011; the last snow storm of the year. I used the color cast to my advantage when converting to black and white.

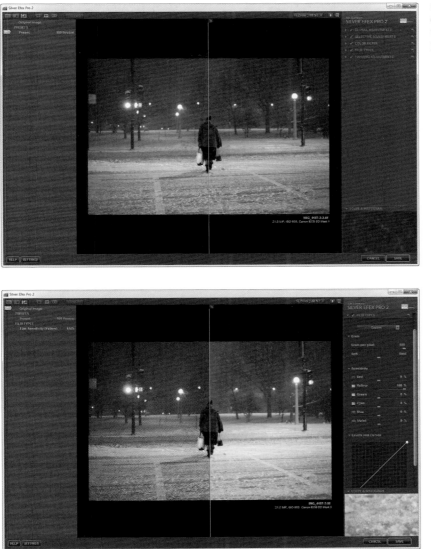

FIGURE 4.8 The default comparison view is set to the (000 Neutral) preset.

FIGURE 4.9 I prefer to set my comparison view to the original color.

Understanding the SEP Interface

Before exploring the SEP interface in detail, you need to spend a few minutes getting to know your way around it and learning a few of the tools you'll be using. Nik Software has done a great job of standardizing many of its plugin's interfaces, so if you know your way around one, you'll have a general feel for the rest of the plugins (**FIGURE 4.10**).

FIGURE 4.10 This main display is where you'll be doing your editing.

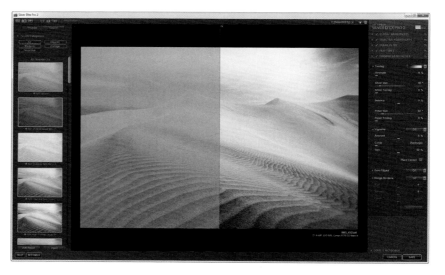

Top Menu

In the top menu you'll see a number of features, such as the browser control, image preview modes, the Zoom tool, and more. Most are depicted by icons. Let's review these top-menu features, starting from left to right.

Browser control

The first three options in the menu control the left panel view primarily, but they also allow you to access important features, such as History. You can collapse the left panel by clicking the Hide Preset Browser icon (**FIGURE 4.11**). To navigate back to the Presets view, click the Show Preset Browser icon. To view image adjustment history, click the Show History Browser icon.

FIGURE 4.11 Change your browser by selecting one of the three options: Hide Preset Browser (a), Show Preset Browser (b), Show History Browser (c).

Image Preview modes

One of the first tasks you should do in SEP is set up how you'll be viewing the images. You have the options of viewing your image in Single Image view, Split Preview, or Side-by-side Preview mode (**FIGURE 4.12**). You can alter your view simply by clicking any one of the three boxes. I begin most of my image edits in the default Split Preview mode, which allows me to make sure that I like the changes I'm making by seeing the before and after in split-screen mode. When I've decided on my processing direction, I'll then select Single Image view to view the image larger and focus on details.

FIGURE 4.12 Click Single Image view (a) or one of the two image-compare views: Split Preview (b) or Side-by-side Preview (c).

Compare button

The Compare button allows you to toggle between the newly edited black-and-white image, the original converted image, or any of the states selected by the History State selector. Keep in mind that the Compare button works only in Single Image view. Simply click the button to compare the images (**FIGURE 4.13**).

FIGURE 4.13 Click the Compare button to toggle between the before-and-after views.

Zoom tool

The Zoom tool is excellent for reviewing images and identifying potential problems, such as dust, noise, or halos. To activate it, click the magnifying glass or press the spacebar; the Navigator window will pop up, enabling you to pan around the image (**FIGURE 4.14**). To toggle back to your original view or change your viewing percentage, click the magnifying glass a second time or press the spacebar. The default is 100%, but you can change the percentage to suit your needs.

FIGURE 4.14
Use the Zoom tool to
magnify your image
for inspection.

Background color

You can change the background color by clicking the Lightbulb icon
(**FIGURE 4.15**) located directly to the right of the Zoom tool. The background
options are black, gray, and white. I prefer to work with the black background
because it helps me visualize the contrast within an image. You'll want to set
this option based on your preference.

Hide/View Adjustments panel

FIGURE 4.15 Click
the Lightbulb icon (a)
to change the back-
ground color. Click the
right arrow (b) to close
the Adjustments panel.

The last tool in the top menu is the Hide or View Adjustments panel. You can
choose to hide the right panel by clicking the right arrow icon (**FIGURE 4.15**),
or you can press the Tab key to close both the left and right panels at the
same time. This is very helpful when analyzing your image and reviewing your
final edits, or whenever you just want a less-cluttered view. Click the right
arrow icon or press the Tab key again to return the panels to the original view.

The Browser Panel

The Browser panel on the left is where you'll find two very important tools:
Presets and the History browser. Let's review each of these features further.

History browser

The History browser is a valuable tool to use to review all the changes you've made to an image in chronological order. Clicking any adjustment will take you back to that state of your image. This is especially helpful if you get carried away and realize you don't like the path you're on. Just click a previous point where you were happy with your changes and continue editing from that point.

HOT TIP

Remember that if you make any adjustments after clicking a previous place in your editing history, you will permanently lose everything you did after that point. However, if you don't make any adjustments, you can click your most recent state and continue editing your image without losing previous edits.

Comparing your edits using the History State selector

Another very helpful way to determine if you like the edits you've made is to use the History State selector (**FIGURE 4.16**) to compare your previous edits to your very last edit. To do this, slide your History State selector to a previous edit that you want to compare to the current image. You can even slide the History State selector as far back as the original color image (as discussed earlier in the chapter) or to its original, converted black-and-white state (000 Neutral) and compare it to your last edited state.

FIGURE 4.16 Use the History State selector to view and compare previous stages in the edit.

I like to use Split Preview when comparing edits using the History State selector. In Split Preview mode, the History State preference is displayed on the left side of the split screen, and the last known image edit (denoted by the orange highlighted text) is displayed on the right.

Presets

The Preset Categories panel on the left side of the screen organizes all of your standard presets as well as any newly imported or customized presets. SEP ships with nearly 40 presets, which are broken down into three categories: Modern, Classic, and Vintage. You can view all of the presets by clicking All (**FIGURE 4.17**) or just view Favorites. To add a preset to Favorites, simply click the star at the bottom of any preset and it will be added to your Favorites list.

Any presets that you created or imported will be accessible by clicking Custom at the top of the Presets panel (**FIGURE 4.18**).

It's important to note that your original imported image is always converted using the top preset labeled 000 Neutral. Think of this as the "reset preset." At any point along the way, if you want to go back to your original image, click the Neutral preset and you'll be taken back to your starting point.

Whenever you select a preset, it makes adjustments, which you can view in the right panel (Adjustments panel). In the image of the leaf in **FIGURE 4.19**, I selected the High Structure (smooth) preset. Notice the adjustments it made to the Structure slider. It increased the Structure and Midtones while decreasing Fine Structure.

Each preset has a unique look and will affect the right panel differently. I'll discuss the right panel controls in a bit, but it's a good habit to select a preset and review its effects in the Adjustments panel. If you like the look of a given preset, you should note the changes that it makes to the Global Adjustments, Color Filters, Film Types, and so on. This information will be very helpful when you decide to go it alone without presets but still want to create a certain effect.

It is very easy to add more presets. You can create your own and save them as custom presets or import new presets from a number of sources. Start by downloading over 40 of Nik's additional presets at www.niksoftware.com/presets or at my blog at www.johnbatdorff.com/pluginwithnik.

FIGURE 4.17
Choose to view a pre-
set by category
or peruse them all.

FIGURE 4.18
Click Custom to view
presets you created
or imported.

FIGURE 4.19
The Structure slider
is one of my favorite
sliders. I use it on
almost all of my images.

Adjustments Panel

You can think of the right panel as the darkroom's digital toolset. There is nothing wrong with clicking a preset and calling it good if you're satisfied, but sometimes a preset just doesn't get your image where you want it. In the Adjustments panel you can be creative and truly take control of your image. The Adjustments panel has been laid out with a typical workflow in mind, meaning that you make adjustments starting at the top (Global Adjustments) and work your way down (Finishing Adjustments). However, this shouldn't stop you from jumping around the panel and making edits as your creative mind sees fit. Let's review the tools in the Adjustments panel and then move to its practical use in processing an image.

Global Adjustments

The Global Adjustments tools—Brightness, Contrast, and Structure—make corrections to an entire image. You can adjust each slider independently, and for greater control within that slider, simply expand it by clicking the disclosure triangle (**FIGURE 4.20**). The Structure slider does a great job of adding texture to an image. This feature is unparalleled by any other black-and-white software. SEP's unique algorithm maps your image into zones, so when you make an adjustment, it changes the pixels based on their individual placement, brightness, and an array of other factors. Remember that you can reset any adjustment you make by clicking the reset arrow on the right.

FIGURE 4.20 Make adjustments to an entire image by using the Brightness, Contrast, and Structure sliders.

Tonality Protection allows photographers to avoid loss of detail in an image's shadows or highlights (**FIGURE 4.21**). This feature is very similar to using Lightroom's Highlights or Shadow adjustment tool.

FIGURE 4.21 Make sure you're not losing any details in your highlights or shadows by using the Tonality Protection feature.

Selective Adjustments

Moving down the panel, the Selective Adjustment section is next. This is probably my favorite tool in the entire Nik Software suite and especially in SEP. You can create a selective adjustment by clicking Add Control Point and positioning the control point on a desired location on your image (**FIGURE 4.22**). Using Nik Software's U-Point technology, you're able to control the tonality, structure, and selective color of any particular region of your image. The ease and precision with which you're able to navigate these adjustments allows you to focus more on the image and worry less about the technical how-to.

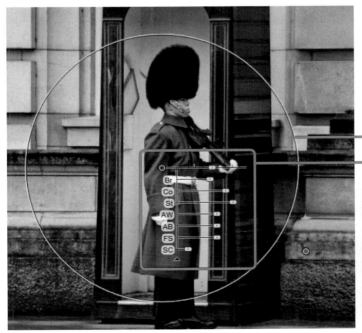

FIGURE 4.22 Use any one or all of the eight fine-tuning sliders to make zoned adjustments to an image. Using the Control Points in the Selective Adjustment section (right panel) gives you ultimate processing control.

BOUNDARY

SELECTIVE ADJUSTMENTS

If you want to visualize the specific region of your image that is being affected by a particular control point, select that control point's Show Selection check box (**FIGURE 4.23**). When you're using the Selective Color option, always turn on this feature to see if you have any spillover in unintended areas of the image (more on that later in this chapter).

It's helpful to group control points that are performing similar functions (such as Selective Color). To group the points, highlight the points in the panel by holding down the Shift key and selecting the points you want to group. Then click the Group Selected Control Point button (**FIGURE 4.24**), which we'll abbreviate as Group, immediately below to group them. Now you can make your adjustments to the grouped control points using one master slider. To ungroup the control points, select the master point and click the Ungroup button. To duplicate a control point, highlight the control point you want to duplicate and press Ctrl+D (Command+D). You can delete a control point by selecting it and clicking the trash can, or by selecting the point and pressing the Delete key.

FIGURE 4.23 Select the Show Selection check box to see what area of the image you are isolating when making adjustments.

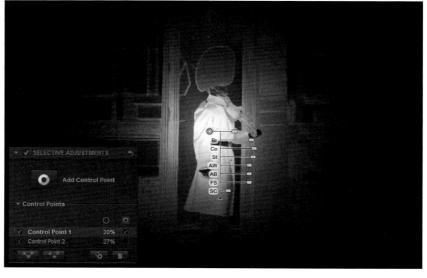

FIGURE 4.24 Grouping your control points can remove a lot of clutter. Use the Group button (a), the Ungroup button (b), the control point (c), and the trash can (d).

Using color filters

Black-and-white photographers have been using color filters to control contrast since long before the digital revolution. But with today's digital cameras, it is no longer necessary to use a color filter at time of capture. SEP users have the ability to simulate color filters by taking advantage of available presets (**FIGURE 4.25**). Instead of carrying color filters, you can now use any of the six easy-to-use filter presets: Neutral (no color effect), Red, Orange, Yellow, Green, or Blue. Alternatively you can use one of the six Color Sensitivity sliders.

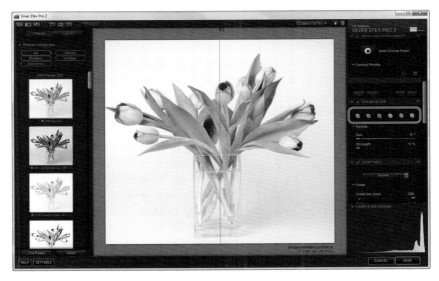

FIGURE 4.25 Silver Efex Pro 2 provides you with the best color filter control over your images. You can increase or decrease the effect of the filter with a simple slider.

The traditional black-and-white filter kit consists of red, yellow, green, and orange filters. These work by absorbing light and lightening colors similar to their own while darkening other colors. Lighter color filters will have minor effects on an image; darker colored filters will have more intense effects. It's useful to understand how each filter works, whether you're using them on-camera or applying the effects in postprocessing. A red filter, for instance, lightens skin tone and darkens green foliage.

In **FIGURES 4.26** through **4.29** you can see how the color image is processed in SEP once the filter has been applied. The left side of the image shows what the unaltered grayscale image looks like; the right side of the image shows what it looks like once the color filter is applied. I like to start by studying the color image. Pay attention to the areas that the filter should affect as well as the overall brightness of the image. All these filters have sliders that control the overall strength of the effect (**FIGURE 4.30**). That's the beauty of using a digital filter.

FIGURE 4.26 This yellow filter absorbs blue, and will darken skies and green grass while lightening anything that is yellow.

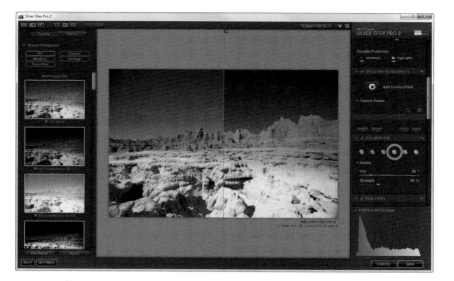

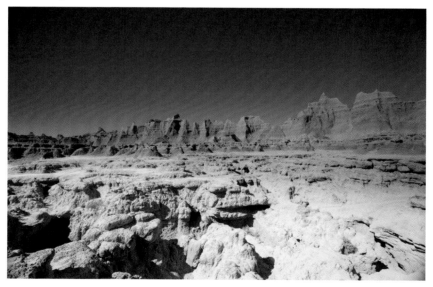

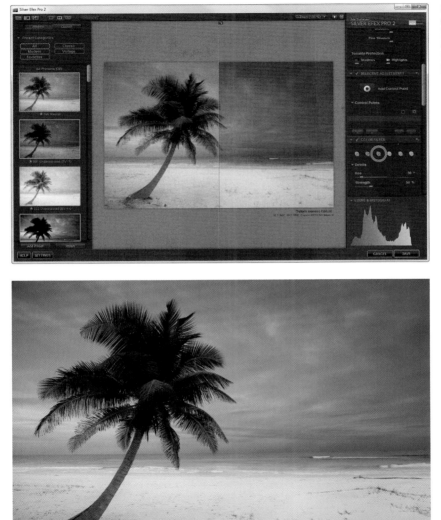

FIGURE 4.27 This orange filter absorbs blue and blue/green, and creates contrast in many landscape images.

FIGURE 4.28 The red filter works by absorbing blue/green and will lighten skin tones.

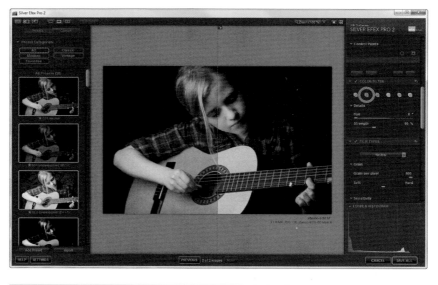

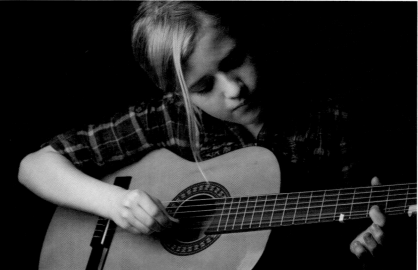

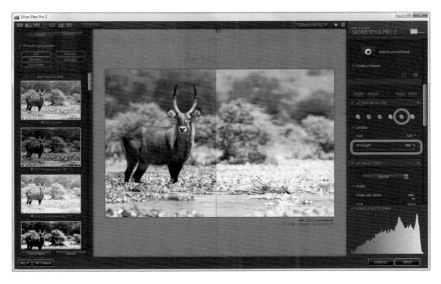

FIGURE 4.29 This green filter absorbs red and lightens green grass.

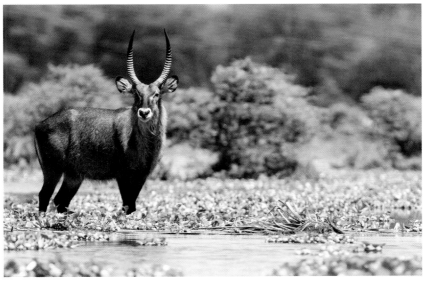

Remember that you can toggle the before/ after preview by selecting the Color Filter check box (**FIGURE 4.30**).

Film Types

Those of you yearning for the good ol' days of film will enjoy working with the Film Types section of SEP. Each of the 18 types of film to choose from simulates a film's sensitivity to color, grain, and tone (**FIGURE 4.31** and **FIGURE 4.32**). As with the other presets,

FIGURE 4.30 Personalize your color adjustment by using the Hue or Strength slider.

you can click and be done with the edit, or customize it further by using the Grain and Hardness sliders. The Grain per pixel slider adds or reduces the amount of visible grain. The Hard/Soft slider adjusts the visible separation between the grain. You can think of these sliders in this way: If you want the image to look noisy or like an old-fashioned image, reduce the grains per pixel and hardness. If you want the image to look modern, do the opposite and increase the grains per pixel to 500 and maximize the hardness.

> **HOT TIP**
>
> If you'll be using a film type, it's always a good idea to set your Levels and Curves after you've completed your film selection because the Film preset will directly affect this selection.

FIGURE 4.31 Use the Film presets to give your digital image the look of classic film.

FIGURE 4.32 Add or reduce grain and size by using the sliders.

Color Sensitivity

You'll love using the Color Sensitivity sliders to control certain colors and color cast within an image. As mentioned earlier, often I won't set the white balance during my night photography and will instead use the yellowish color temperature to my advantage when converting the image to black and white. The Color Sensitivity sliders are a great way to lighten or darken a particular color by moving the sliders to the left to darken or the right to lighten (**FIGURE 4.33**).

Levels and Curves

The Levels and Curves feature (**FIGURE 4.34**) controls the brightness and contrast of an image's tones. To add a point, either click the graph, or using my preferred method, click the line and drag it up or down. To remove a point, double-click the point. To be honest, this is one feature I don't use very often while in SEP unless a preset that I'm using sets it for me. I prefer to work the tone curve in Lightroom or Photoshop after I've finished converting the image in SEP. The reasons for this are twofold: First, the tone curve in SEP seems to be a bit crude, whereas the one in Lightroom has a few more bells and whistles. Second, I don't like being locked into my tone curve settings "forever," which is the case for non-Photoshop users (I'll explain that further in Chapter 7). Although it's still best to do most of your postprocessing in SEP, leave the tone curve adjustments for Lightroom. You'll gain the flexibility of being able to revisit the tone curve as often as you deem necessary.

FIGURE 4.33 Use the Color Sensitivity sliders to control individual colors within an image.

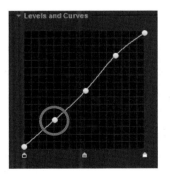

FIGURE 4.34 I'll often create a gentle S with the tone curve setting.

Finishing Adjustments

The Finishing Adjustments allow you to get creative with your images by applying old-school darkroom techniques, such as toning, vignettes, borders, and burned edges. Toning is a term used in the darkroom for changing the color or tone of a print. Sepia and Selenium (**FIGURE 4.35**) are two popular examples of this technique. The beauty of today's digital darkroom is that you no longer need chemicals to change the silver in an image or the color of the paper. You can use one of the 23 presets or create your own custom tone by using the Silver and Paper sliders. Although I don't do a lot of toning in my images, I'll show you one example and then move on to spend more time on vignettes, burned edges, and image borders—all of which I use often.

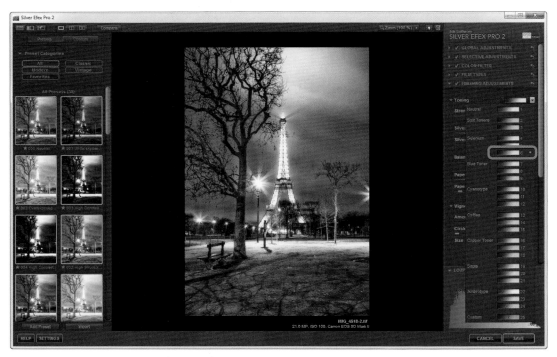

FIGURE 4.35 I used the Selenium (number 6) tone to add to the cool temperature of an early spring evening in Paris.

The Finishing Adjustments sliders have always been confusing, so you might find it helpful to think of them in these terms:

- Silver equals the dark areas of an image.

- Paper equals the light areas of an image.

- Strength (**FIGURE 4.36**) increases or decreases the saturation of the tone on the entire image.

- Silver Hue is the color that will be applied to the dark tones of an image.

- Silver (dark area) Toning is the overall strength of the hue's dark tones.

- Balance is the blending of the effect between the dark and light areas of an image. Moving the slider to the left increases the effect applied to the dark areas of an image; moving the slider to the right affects the toning applied to the light areas of an image.

FIGURE 4.36 Use the Strength slider to increase or decrease the saturation of a tone.

- Paper Hue is the tone applied to the light tones of an image.

- Paper toning is the overall strength of the hue on the light tones.

Vignettes, Burn Edges, and Image Borders

A vignette allows you to darken or lighten the edges of an image to give it a natural frame and draw the eye to the focus point. A vignette can be either circular or rectangular. In SEP you can use one of the seven presets or manually place the center location of the vignette exactly where you want it using the Place Center tool.

Burn Edges is an incredibly handy tool for directing viewers' attention to your subject. In **FIGURE 4.37** I burned in around the bottom to help draw attention to the tree shadows. This feature can also work like a Gradient tool to darken an overexposed sky.

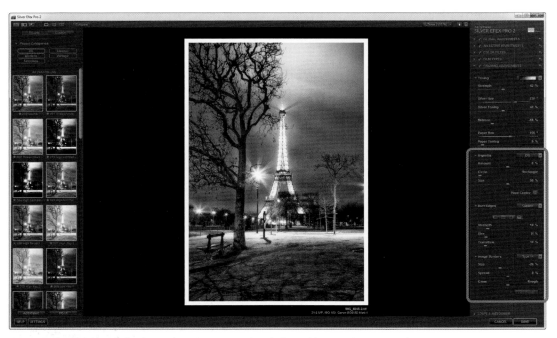

FIGURE 4.37 Finishing Adjustments has a great set of tools for making your image stand out.

Using the Image Borders feature is a great way to polish your image's presentation. I used a classic white border (Type 14) on the image of the Eiffel Tower. You can select from one of the 14 presets and customize the effect from there using the sliders. When you select certain presets, you have the option of using the Vary Border feature, which is a slick tool that generates variations of any particular style. Simply click through them to see the variations on your selected border.

Creating Your Own Presets

Presets are great for speeding up your workflow and guaranteeing a consistent look and feel. However, the downside is that everyone has the same presets available to them, so many of your images will have a "SEP" look to them. I'm guilty of this as well; so one of the ways to set your processing apart from the rest is to create presets that are unique to you. That, of course, doesn't mean reinventing the wheel. There's nothing wrong with starting off with a Nik preset, making a few tweaks, and saving it as your own.

Before you get started, locate an image you want to edit and follow the steps in the exercise as I work on my image. Any of your images that have a nice earthy or nostalgic feel will work wonderfully. I'll create a preset using the image in **FIGURE 4.38**, which I shot in rural Jamaica a few years ago. I shot film for years, and although I don't miss working in the darkroom, I do miss the look of a black-and-white image produced from film. SEP has done a great job of simulating many of the popular films, so let's create a custom preset by starting with Film Types.

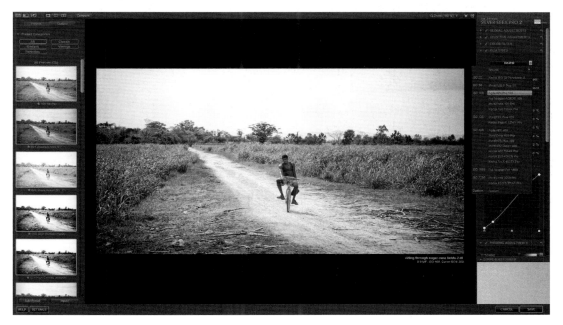

FIGURE 4.38 Film presets do a great job simulating film.

1. Select the Agra APX Pro 100 film type. This film type is ideal for expressively reproducing scenes with action or moments of quiet.

2. In the Finishing Adjustments, move the Toning Strength slider to the right until you achieve a nice sepia look.

3. Apply a small vignette by using the lens Falloff 1 preset, and then reduce the effect by moving the slider to the right.

4. To create a preset that you can use in the future based on these settings, select Add Preset in the Preset Browser's left panel. A window appears in which you can enter your new preset's name. Click OK. You now have that preset available to you in the custom presets window for future use (**FIGURE 4.39**).

FIGURE 4.39 Creating your own preset takes only a few clicks of the mouse.

Using Selective Colorization

One of the best features in SEP is the ability to "selectively" introduce color back into a grayscale image. I don't do a lot of selective color, but when I do, I try to make it really count. The trick is to not overdo it. Let's take a look at the image of the leaves on the rock (**FIGURE 4.40**). Once again, select an image you want to edit, but this time focus on an image that has one or two dominant colors. Although I like how my image looks, it could really pop with a little color added back into it, so let's explore that now.

FIGURE 4.40 High Structure (smooth) is one of my favorite presets.

1. Select the High Structure (smooth) preset.

2. When you're using Selective Color, it's critical to know which areas you want to select. Click the Show History Browser icon, click the Split Preview icon, and slide the History State selector to the top where it displays Original Image. Now you can identify the areas where you want to add color simply by moving the split-screen slider (red line) to the left or right (**FIGURE 4.41**).

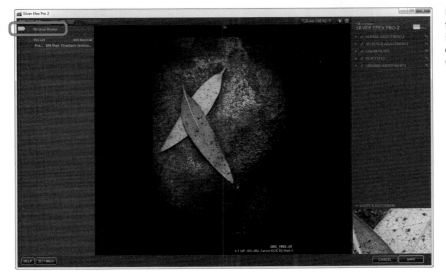

FIGURE 4.41 Seeing the original color image is very helpful when creating a Selective Color image.

3. Close the left panel by clicking Show Image Only at the top and then head over to Selective Adjustments in the right panel. To add color back into your selected image area (in my example, the leaves), add a control point by clicking Add Control Point or by pressing Ctrl+Shift+A (Command+Shift+A). Because adding color may require several steps, place the control point in the center of the area where you want to add color. The Loupe view can be very helpful to pinpoint areas where you want to add control points. Make sure the control point's boundary (size of circle) covers the areas of the object but doesn't cover beyond the area where you intend to add color.

4. "Turn on" the color by moving the Selective Colorization slider to the right. To mute the colors a bit, move the slider to 85%. As in the example, you might notice a little bit of overspray of color on other objects in the image, but don't worry; you'll fix that next (**FIGURE 4.42**).

FIGURE 4.42 Make sure your boundary isn't too large but that it covers just the area you want to affect.

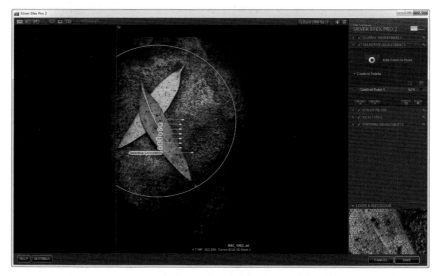

5. Select the Show Selection check box for Control Point 1 so you can see the area being affected (**FIGURE 4.43**).

6. Click a control point and place it on an area where you don't want color. I refer to this as a neutral control point to help reduce the overspray of color. Repeat this step as many times as necessary.

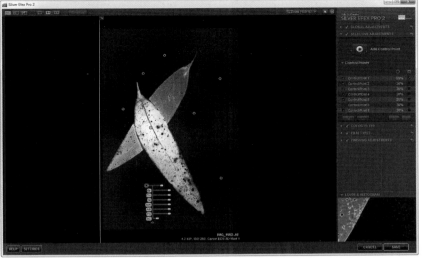

FIGURE 4.43 Use neutral control points to chisel away areas where you don't want color.

7. Deselect Show Selection so you can see your subject in color again. Notice that you've effectively eliminated any overspray. Neutral control points don't work 100 percent of the time; therefore, you may need to revisit your image, place a new control point on the area where you want to add color, and increase the Selective Colorization slider again (**FIGURE 4.44**).

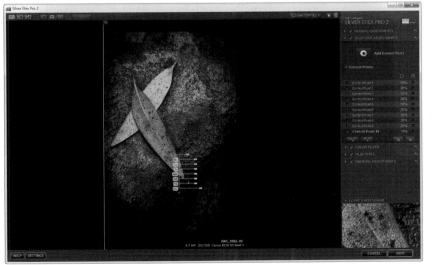

FIGURE 4.44 Repeat adding Selective Color points as needed to refine the image.

HOT TIP

To make your Selective Color image pop, once you're back in your host program, use Vibrance or Saturation to increase the color portion of your image.

Processing an Image: From Start to Finish

You've spent most of this chapter dissecting all the great tools SEP has to offer. Now let's put those tools to good use and process a few images.

Creating a Landscape

The key to creating a dynamic black-and-white landscape image is keeping it simple and accentuating the obvious. **FIGURE 4.45** shows an image I took at Mono Lake, California. When processing an image, you first need to analyze it and think about what it is that makes it good. In this instance it boils down to three compositional elements: the billowing clouds, the mountains in the distance, and the reflection of the clouds in the water. The image appears a little flat, but the histogram indicates that there is a decent tonal range to work with.

FIGURE 4.45 A decent tonal range spans from the shadows to the highlights.

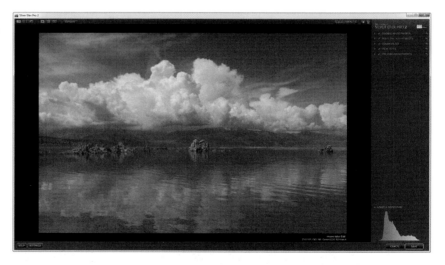

Although the current tonal range is good, it would be better if the final image had a high amount of contrast as well as increased texture. The goal is to make the clouds appear almost three-dimensional by darkening the sky and adding texture to the clouds.

Let's begin by using the High Structure (smooth) preset (**FIGURE 4.46**). I typically use the same preset 70 percent of the time because it ensures that my

style stays consistent. (However, you can use whichever preset you feel is necessary when developing your vision.)

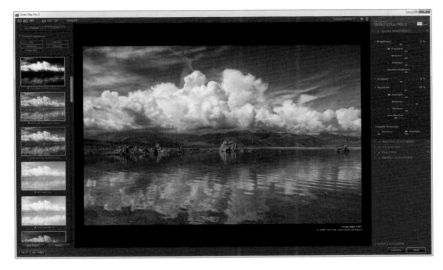

FIGURE 4.46 The High Structure (smooth) preset adds more structure to the midtones.

Darken the sky

We can skip the Global Adjustments because the preset has set those already and they look good. Taking control of the sky and darkening it without affecting the clouds is the next step. To do this, we'll use the Blue Color Sensitivity slider located under Film Types and slide it to the left to darken the sky (**FIGURE 4.47**).

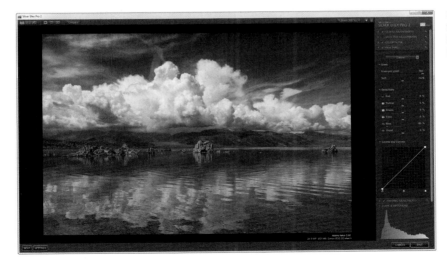

FIGURE 4.47 Moving the Blue Color Sensitivity slider to the left darkened the sky.

Dynamic clouds

Next, head to Selective Adjustments and add control points to the clouds. To add a control point, simply click Add Control Point or press Ctrl+Shift+A (Command+Shift+A).

The key to making a good selection with your control point is to use your histogram's zones and identify the best location to drop your control point for the maximum effect. In this example, Zone 8 covers most of the highlight region of the clouds, so placing a control point on pixels that fall within that zone is needed. Once the control point is placed in the right location, it's critical to make sure the control point size, or boundary, is large enough to encompass all of the clouds. Also, cranking up the Structure slider adds texture to the clouds and makes them pop (**FIGURE 4.48**).

FIGURE 4.48 The Structure slider does a great job of adding texture to an image.

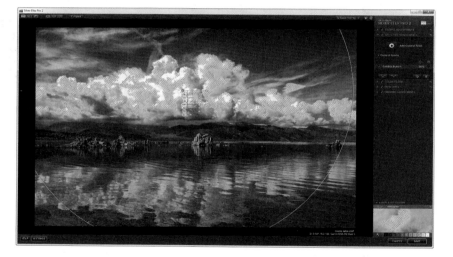

The final image now meets the original goals. The subtle enhancements to the sky wouldn't have been achievable by using only a preset (**FIGURE 4.49**).

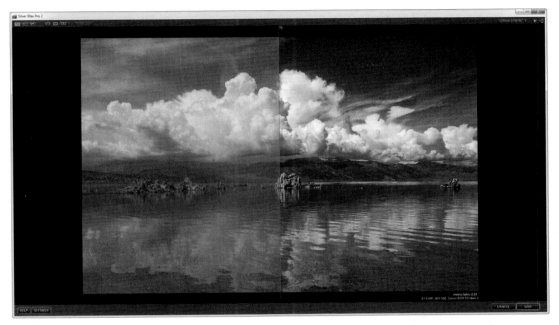

FIGURE 4.49 Notice how the sky pops now compared to the default conversion.

Creating a Portrait

Creating an interesting portrait is about finding the balance between show-casing your subject's personality and integrating your own personal style as a photographer. For those of you who follow my blog, you'll quickly recognize my daughter Anna in the photograph used in this exercise. She's been an inspiration and source of silliness throughout the years. There's very little that is dark about her personality, so a high-key image would work well for her portrait. Matching the mood to the key is very important. For solemn or serious subjects, a low-key or dark image works well, but for happy or funny moments, a high-key or light image is more appropriate. Knowing your sub-jects and their personalities, and matching them to the key of the image, is critical for setting the tone of a black-and-white portrait.

Beyond balancing the mood, it's also important to highlight the unique physi-cal features of your subject, which in this photo is Anna's blue eyes and smile. The goal is to create a high-key image and draw attention to her eyes and smile without being distracted by the background or clothing.

Creating a high-key image

Let's start by using the Overexposed Preset (Ev+1). Click the Overexposed Preset (Ev+1) in the Preset panel to create a nice baseline. Then click Show Image Only view so that only the image and the Adjustments panel are open (**FIGURE 4.50**).

FIGURE 4.50 The Overexposed Preset is a good starting place for this high-key image.

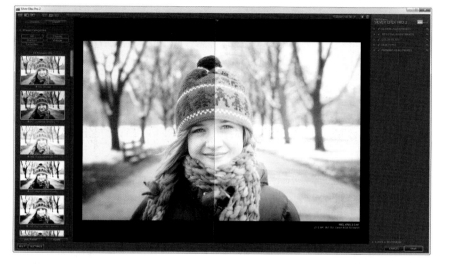

This image is now very bright. Using the Dynamic Brightness slider, darken the image a bit by moving it to the left. The image needs to be high-key but not blown out. Add a little detail back into the midtones by increasing the Midtone Structure slider to the right (**FIGURE 4.51**).

The background is still a little distracting, so let's place four control points strategically around the subject to help shape the high-key image. Remember to draw the boundary so it's affecting only the area you want to adjust. Next, group the control points by holding down the Shift key and clicking each point until they're all selected; then click the Group Control Point button or press Ctrl+G (Command+G). Using the master control point, decrease the Structure to 0 and increase the Brightness to 50% (**FIGURE 4.52**).

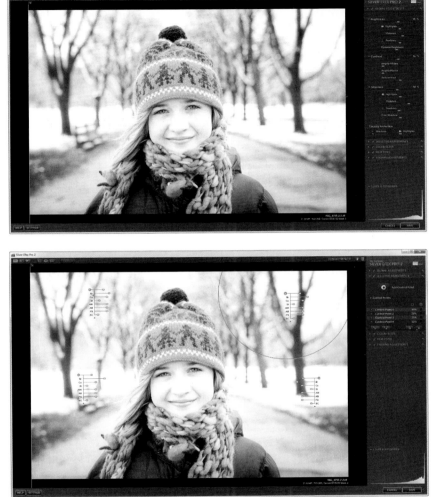

FIGURE 4.51 Use the Midtone Structure slider to increase details in the midtones.

FIGURE 4.52 Using control points, you can effectively dodge (lighten) or burn (darken) in a background.

You might be wondering why you did all that work with the midtones just to undo it now. Remember that Global Adjustments affect the entire image; the goal was to increase the midtone details in Anna's hair, hat, and jacket but not add to the distracting background. So, by using control points, you're able to chisel away at the effect.

All about the eyes

Now it's time to bring out the details in her eyes and accentuate her smile. Create two small boundary control points in the colored part, or iris, of the eye. I strongly recommend using the Loupe view to assist in placing the control point. Group the two control points and increase the master control point's Structure slider to 50%. To accentuate the smile, add another control point where the lips meet and increase the structure to 30% (**FIGURE 4.53**).

FIGURE 4.53 Using the Loupe view can be very helpful when placing your control point.

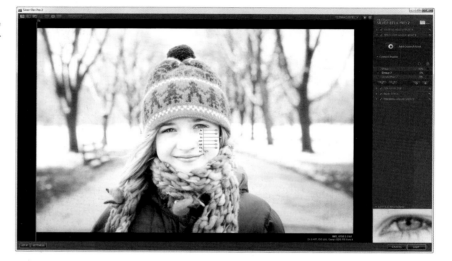

Working the Color Sensitivity sliders

The Color Sensitivity sliders located under Film Types work great when you're trying to adjust contrast within an image. In this case, the color sliders are used to adjust the contrast of the background, Anna's hat, eyes, and face. Decreasing the red slider by 50% darkens her hat, skin tone, and lips. Increasing the blue slider lightens her eyes, and adjusting the yellow and violet sliders tweaks the color in her hat (**FIGURE 4.54**).

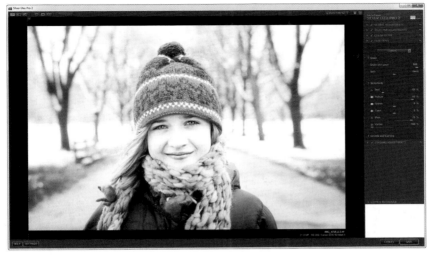

FIGURE 4.54 The color sliders work well when increasing or decreasing a particular tone.

Now compare the edited version against the original black-and-white image to see that the goals for this image have been accomplished (**FIGURE 4.55**).

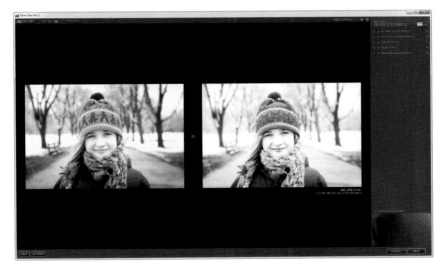

FIGURE 4.55 Notice how the background has less definition, whereas Anna's eyes and smile pop.

Toning an Image

Toning an image can be a creative way to deal with images that are very flat or gray by nature. **FIGURE 4.56** shows an image I photographed of two male elephants fighting for dominance. Although I thought this image would make an interesting black and white, none of my editing attempts seemed to do it justice until I decided to head down the road of using a Cool preset. Let's work this image together. You'll first need to register your book so that you can download this image from www.peachpit.com/nikplugin. Once registered, open the file elephant.start.tif and follow along with me to practice toning this image.

Click the Cool Tone 1 preset and switch to Show Image Only view. Although this preset is a great starting point, it needs some tweaking. Notice how blown out the highlights are in the center of the image and how little detail is in the shadows. To bring that detail back to the highlights, you need to move the Highlights Tonality Protection slider all the way to the right. To gain back some detail in the shadows, jump down to the Finishing Adjustments to back off of the vignette that the preset created. Then increase the Shadow Tonality Protection slider to bring detail back into the shadows.

FIGURE 4.56 The tonality sliders do a great job of adding back lost detail in the shadows and highlights.

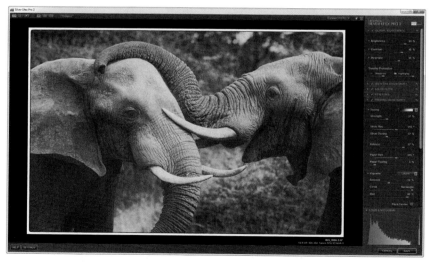

Now it's time to add texture to the elephants' heads by creating a group of control points and placing them along the elephants' heads and trunks. Using a master control point, increase the Structure to 100% and Fine Structure to 32% (**FIGURE 4.57**).

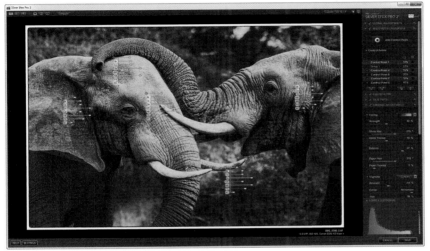

FIGURE 4.57 Grouping control points that perform similar functions saves time.

To really make the elephants stand out, you need to burn in the background. To do this, place a few control points in the background and create a group, but this time instead of increasing the Structure, decrease the Brightness to -60%, Structure to -100%, and Fine Structure to -100% (**FIGURE 4.58**).

FIGURE 4.58 Using a group of control points to burn in the background.

Finally, add some finishing touches by increasing the Toning strength to 50% and changing the border to a cleaner look by selecting a Type 14, which I like better than the preset's default (**FIGURE 4.59**).

FIGURE 4.59 Using the Finishing Adjustments tools should be one of the last things you do prior to saving an image.

FIGURE 4.60 compares the image to the original Cool Tone 1 preset that was used at the start. The goals of showcasing the texture and adding a unique tone to the image were definitely achieved.

FIGURE 4.60 Notice the detail in the trunks and shadow regions of the image.

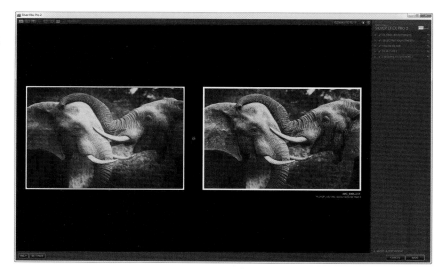

Top Ten Tips for SEP2

As a quick review, I'll share my favorite tips for efficiently editing great black-and-white images. See Table 4.1 for Silver Efex Pro keyboard shortcuts.

1. Add to your preset collections by downloading new presets from Nik Software.

2. Before you start using presets and moving sliders, spend time analyzing your image and visualizing the final outcome.

3. If you don't like the direction in which you're heading, use your History Browser to go back a few steps instead of starting all over again.

4. Selective Color is ten times easier when you use the compare view while the History State selector displays Original Image.

5. The Loupe view is best for identifying the exact place to place a control point.

6. Use the Histogram Zones to help identify similar tones throughout an image.

7. Press the Tab key to hide the panels and focus only on your image from time to time. To bring the panels back, just press the Tab key again.

8. If you want consistency in your style, create a preset that's unique to you.

9. If I had only three tools to use, they would be the Dynamic Brightness, Structure, and Color Sensitivity sliders.

10. Group control points that are performing similar functions.

TABLE 4.1 Keyboard Shortcuts for Silver Efex Pro 2

	WINDOWS	MACINTOSH
INTERFACE		
Undo	Ctrl+Z	Command+Z
Redo	Ctrl+Y	Command+Y
Full screen	F	F
Compare/Preview	P	P
Zoom	spacebar	spacebar
Show/hide panels	Tab	Tab
Save	Enter	Return
Close application	Esc	Esc
CONTROL POINTS		
Add control point	Ctrl+Shift+A	Command+Shift+A
Delete control point (while selected)	Delete	Delete
Duplicate control point	Ctrl+D	Command+D
Copy control point	Ctrl+C	Command+C
Paste control point	Ctrl+V	Command+V
Expand/Collapse control points	E	E
Group control points (while selected)	Ctrl+G	Command+G
Ungroup control points (while selected)	Ctrl+Shift+G	Command+Shift+G

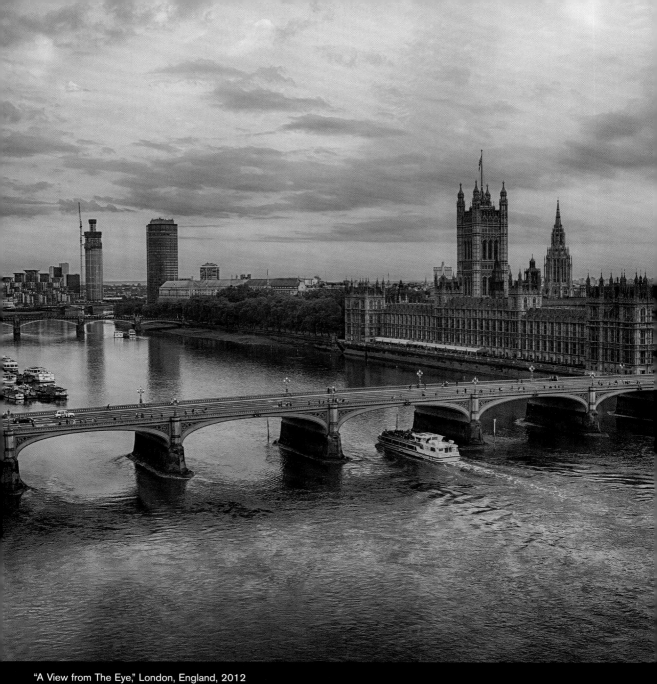

"A View from The Eye," London, England, 2012

Canon Mark III 35mm 1/125 @ f/5.6 ISO 500

HDR EFEX PRO 2

Never has there been a technique as loved, hated, and simultaneously misunderstood as high dynamic range (HDR). HDR is nothing new. It has been practiced by the masters for decades in the darkroom and has now found its way into the mainstream. Truth be told, a few years ago I might have dreaded writing this chapter because I didn't use HDR Efex Pro very often. But since its reincarnation and the release of version 2, it has become an essential part of my image processing. This program's algorithm has been redesigned to create very realistic, as well as creative, renditions. It's a landscape photographer's dream come true.

In this chapter, I'll demystify the HDR process while pointing out the practical, authentic, and sometimes zany applications of this technique. Because it has been totally revamped, I'll explain the entire HDR Efex Pro interface, provide a demo of how I use the product, and share with you my top ten favorite tips for an HDR image.

What Is HDR?

Human eyes are capable of seeing a range of light and colors beyond that of a standard, low dynamic range image. By definition, the dynamic range for a scene is a ratio of the difference between the lightest and darkest zones. When you're creating an HDR image, the goal is to increase the degree of difference, or ratio, between these zones. By increasing the dynamic range, you're able to create images that more closely represent how your eyes interpreted the scene.

Two Approaches for Creating an HDR Image

I'll explain the two approaches to creating an HDR image—single image tone mapping and multiple image tone mapping—so that as you move through the HDR Efex Pro 2 (HEP2) interface, you'll have a solid foundation in understanding the processes.

Single image tone mapping

The simplest way to create an HDR image is to select a single image from your host program (for example, Adobe Lightroom, Adobe Photoshop, Apple Aperture) and export it into HEP2. Upon exporting your image, HEP2 uses a unique algorithm to generate a tone-mapped image for you to edit. Many consider this technique to be cheating or creating a faux HDR image because you're not using multiple images to create a true HDR image. The reality is that sometimes you don't have the opportunity to take several images to create a "true" HDR image, but you should still give it a try if that is your vision for the image (**FIGURE 5.1**). This is considered heresy in some small circles, but I've used this technique successfully on many occasions and have experienced some sweet success as well as my fair share of failures.

FIGURE 5.1 Often, a single image tone mapping can create a wonderful surprise.

THE PROS AND CONS OF CREATING A TONE MAPPED IMAGE FROM A SINGLE FRAME

Advantages:

- It is a simple workflow.
- Fewer images are required.
- Less disk space is required.
- A tripod is not necessary.

Disadvantages:

- More digital noise can be introduced.
- The dynamic range depends on one frame.
- Ghosting can't be minimized by using an alternative frame.
- Proper exposure is critical.
- The true dynamic range of the scene is never truly exploited.

Multiple image tone mapping

You create a true HDR image by taking several exposures of the same scene while extending the exposures to cover the highlights and shadows in the image. The easiest way to achieve these exposures is by using your camera's Auto Exposure Bracketing (AEB) setting, which I'll discuss later in the "Bracketing the shot" section. You later export this bracketed series of images out of your host program and then merge them together to create an HDR image.

THE PROS AND CONS OF CREATING A TONE MAPPED IMAGE FROM THREE BRACKETED IMAGES

Advantages:

- You have greater control over the merging process.

- Ghosting is reduced.

- Dynamic range is increased.

Disadvantages:

- You have multiple images to manage.

- More processing time is needed.

- A steady surface or tripod is a must!

Best Practices for Creating an HDR Image

To maximize the benefits of HEP2, you need to capture a series of exposures that will result in a quality tone mapped image. I like to concentrate on four main goals to make this happen: properly composing the image, minimizing ghosting, nailing the camera settings, and bracketing the shot.

Composing the image

Although this might sound basic, not every image looks great as an HDR image. Just because the light isn't ideal doesn't mean HDR will fix the problem. Think of HDR as an exaggerator versus a liar, meaning it enhances what already exists but cannot create something out of thin air. If you have a nice

sunset and your eyes pick up on multiple shades of red, purple, and blue, HDR will bring that image to life! But if the scene is flat or the light is harsh or lacking color, chances are that HDR will do little to improve your image.

Minimizing ghosting

You don't need an education in paranormal activity to avoid ghosting. Ghosting becomes apparent when you capture movement between exposures and composite it into a final tone mapped image (**FIGURE 5.2**). The best way to avoid ghosting is to make sure you're using a stable surface when taking your image. I always recommend using a tripod with a cable release to minimize camera shake. Generally speaking, you should avoid moving objects, such as people, animals, branches in the wind, and so on.

FIGURE 5.2 Minimize ghosting by using a tripod and being hyper-aware of motion in the scene.

Nailing the camera settings

To avoid headaches and possibly heartache, you should always try to standardize your camera's settings when you're shooting for HDR. These five steps will reward you in the end.

1. Use the lowest possible ISO to help with noise reduction. HDR accentuates noise, so anything you can do to avoid or reduce noise will always be rewarded in the final image.

2. If you're using a zoom lens, it's always recommended to focus on your image first, then set your camera's focus to manual so that it doesn't try to focus again while you're shooting.

3. Set your camera to Aperture Priority so that your depth of field doesn't change during the exposure. For those of you who are comfortable shooting in manual mode, set your camera to manual exposure and adjust your white balance accordingly.

4. Shoot in the RAW file format whenever possible. Although it's possible to shoot JPEG images to create an HDR image, it's highly recommended to use RAW to create the highest quality image.

5. If your camera has a mirror, consider activating your camera's mirror-up feature to help reduce camera shake.

Bracketing the shot

Many techniques exist for bracketing your shot, but the most straightforward is to use your camera's AEB setting (**FIGURE 5.3**). Start by establishing a properly exposed image that provides adequate detail in the shadows and highlights. This will be your middle exposure, or 0 in the bracketed sequence. Once you've established your baseline, create a bracket series of exposures surrounding the baseline exposure. Use your camera's AEB setting or manually take three images two stops apart (-2, 0, 2), or five images that are one stop apart (-2, -1, 0, +1, +2).

FIGURE 5.3 Bracketing your image is easy with the AEB setting. See your camera's manual to find this feature.

HDR has become such a popular form of photography that many of today's cameras even come equipped with an HDR setting built into the menu (**FIGURE 5.4**).

FIGURE 5.4 Check your camera's manual to see if you have a built-in HDR feature.

Managing Your Images

Image management is critical for any serious photographer, but when it comes to HDR photography, it's an outright necessity, especially when you're compiling multiple exposures. Host programs like Lightroom, Aperture, and Adobe Bridge make it easy to assign labels, tags, or ratings to your series of images. I like to keep management very simple, so I use a Blue color label to tag my HDR series to sort them easily for export (**FIGURE 5.5**).

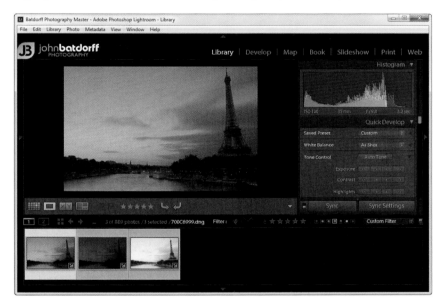

FIGURE 5.5 Use labels or tags to help organize your images.

Once you have your series of images sorted, it's time to prep your images for export. The following sections provide a quick checklist of tasks to complete before exporting your images.

Reduce noise

Review your series of images to make sure they are free of noise. Use Dfine or your RAW converter's software to apply noise reduction (**FIGURE 5.6**). See Chapter 1, "Dfine 2.0," to learn more.

Turn off Sharpening

Make sure all Sharpening is turned off in your host program (such as Lightroom or Aperture) to avoid introducing unwanted artifacts and noise.

Standardize and synchronize

To minimize ghosting and to aid in the HDR merger, it's critical that all your images are identical with the exception of exposure. Using the middle, or 0, exposure, set the correct white balance. Next, make sure the image is cropped exactly as you want it. Finally, make any final adjustments, such as spot removal or lens correction, and click Synchronize (**FIGURE 5.7**).

FIGURE 5.6 Be sure to reduce noise prior to exporting into HEP2.

FIGURE 5.7
Use the Synchronize feature to standardize your images.

Color Settings

It's good practice to double-check your color space and set it accordingly. By default, HEP2 uses the RGB Working Space for image rendering. I like to do all my work using ProPhoto RGB because it provides the widest range of any color space.

CHANGING YOUR COLOR SPACE

Find your host program in the following list and choose the menu items:

- **Lightroom users.** Choose Export > HDR Efex Pro 2 preset > File settings > Color Space (**FIGURE 5.8**).

- **Aperture users.** Choose Preferences > Export tab > Export editor color space.

- **Photoshop users.** Choose Edit > Color Space and select the appropriate color space.

FIGURE 5.8 Select your preferred color space.

Exporting Your Images

Now that you've prepped your images, it's time to export them into HEP2 (**FIGURE 5.9**).

FIGURE 5.9 Right-click to access the Export dialog box in Lightroom.

Lightroom and Aperture users

Select the image or series of images you want to export. Lightroom users need to choose File > Export with Preset > HDR Efex Pro 2. Aperture users need to choose Photos > Edit with Plugin > HDR Efex Pro 2.

Photoshop users

Photoshop users who are working with a single image should choose Filters > HDR Efex Pro 2.

Photoshop users who are merging several images need to choose File > Automate > Merge to HDR Efex Pro 2. Once the HDR Efex Pro 2 Image Selection dialog box opens, click the Open button to open the browser and select your images. If all your images are open in Photoshop, click Add Open Files (**FIGURE 5.10**).

FIGURE 5.10
Remember to have
only those images
open in Photoshop that
you want to merge.

To remove an image from the merge list, simply highlight it and click the Remove button.

Select the Create Smart Object check box if you want to convert your image to a Smart Object so that you can apply HEP2 as a Smart Filter. The advantage is that you can revisit your images in HEP2 and edit your settings as often as you want. To learn more about Smart Objects and their benefits, review the "What Is a Smart Object?" section in Chapter 7, "Advanced Techniques in Photoshop."

Click the Merge Dialog button when you're ready to merge your images. The Merge Dialog interface appears and provides a 32-bit HDR preview of your merged sequence of images.

Merge Dialog Interface

When you export a series of images into HEP2, you're first presented with the Merge Dialog interface (**FIGURE 5.11**). It's here that you will fine-tune your image merge to further avoid any ghosting or chromatic aberrations.

I love this tool because it puts you, the photographer, in control of the merge and allows you to gain creative control prior to the tone mapping. Let's review how the Merge Dialog interface works. Start by ensuring that all of your selected images are present and that nothing was lost during export.

FIGURE 5.11
Use the Merge Dialog
interface to preview
the merge and check
exposures. Use the
Preview Brightness
slider (A) to help
identify ghosting.

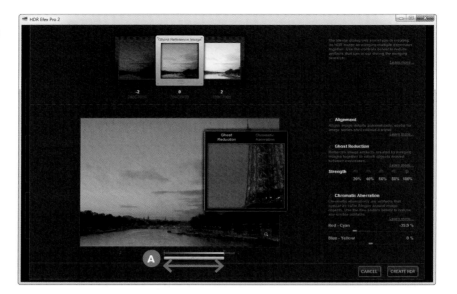

Next, preview your image in the main window to determine if the alignment is accurate or if any ghosting has appeared. I recommend using the Preview Brightness slider to help identify areas where ghosting and alignment issues may have occurred. Moving the slider will not affect the final outcome of the merged HDR.

Alignment

Problems with alignment can happen for a variety of reasons, but often they are a result of camera shake. Movement during an exposure manifests as artifacts or ghosting in an image. To overcome alignment issues, select the Alignment check box to take advantage of HEP2's unique algorithm to ensure the correct alignment. Once selected, the preview window will update with a new image.

Ghost Reduction

Ghost Reduction is one of the coolest features Nik has added to HEP2, hands down, and is guaranteed to be the Ghostbusters of the HDR world. Sometimes it's impossible to avoid movement throughout an entire series of images, so to remove unwanted movement, select the Ghost Reduction check box to activate the Ghost Reference Image selector (**FIGURE 5.12**). Use this selector to identify which frame you want to use as the baseline or reference for movement throughout the scene. The Ghost Reduction algorithm will then try to match movement to this reference frame.

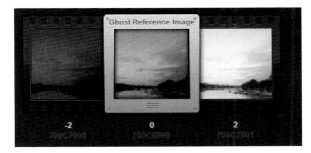

FIGURE 5.12
Select an image that best represents how you want moving objects to appear.

Next, select the desired Strength of the Ghost Reduction. The default value of 100% Strength is recommended for most situations, but on occasion this will introduce unwanted artifacts. If undesired artifacts do appear as a result of the Ghost Reduction algorithm, reduce the Strength until the artifacts fade away. The preview window will update for your inspection as you adjust the Strength percentage. Use the Ghost Reduction Loupe tool (**FIGURE 5.13**) to examine a preview of the merged HDR image for closer inspection. If ghosting is still present, try selecting a new Ghost Reference frame.

FIGURE 5.13 Use the Loupe tool's zoomed view to examine your image for ghosting and chromatic aberrations.

Chromatic aberrations

Select the Chromatic Aberrations check box to reduce aberrations that become visible as color fringes around an object. Activate the Chromatic Aberration Loupe View by clicking the magnifying glass icon and selecting Chromatic Aberration. Use this tool to examine your non-HDR image at 100 percent (**FIGURE 5.14**). Often, color fringe will appear on the edges of objects, such as buildings and areas of high contrast. Use the Red-Cyan slider or Blue-Yellow slider to reduce the color edges as needed.

FIGURE 5.14 Chromatic aberrations appear as odd colorations that outline edges.

The HEP2 Interface

Nik has totally reworked the HEP2 interface to make it more intuitive and suitable to a wide variety of photographers (**FIGURE 5.15**). I was lucky enough to be part of the beta testing team, and when I heard that one of the goals was to create a more realistic HDR image, I was truly stoked about the potential this would represent for my landscape photography. Now the interface has an impressive set of tools to appeal to all creative visions, ranging from very realistic to far-flung fantasy and everything in between. Let's start by reviewing the interface and what it has to offer to you.

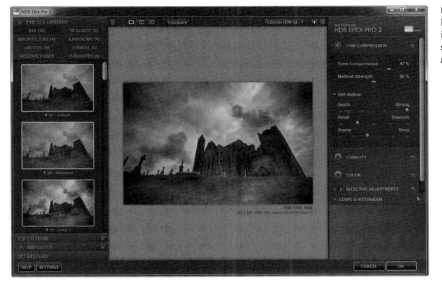

FIGURE 5.15
Nik's totally redesigned interface has in impressive list of presets and tools.

Left Panel Adjustments

The left panel is where you begin your visual journey and guide your creative direction. Presets are a great way to jump-start an image and learn how particular adjustments affect an image. The left panel is also a point of organization for your own presets or those that you've imported. One of the most important tools you'll use in the left panel is the History browser; it chronologically details every edit you make to an image. Let's explore all the features in the left panel further (**FIGURE 5.16**).

FIGURE 5.16 Preview your image in the preset library to see how a particular preset will affect your image.

Preset Library panel

The Preset Library hosts all of your default presets, which are organized in easy-to-access categories. Selecting a category will filter the view of the available presets based on the category selection. This can be very handy when you want to navigate quickly through preset options. My preferred method for navigating presets is to add a preset to my Favorites by clicking the star located on the far left of the preset's name (**FIGURE 5.17**). Once selected, you can access your favorite preset easily from the Favorites category.

FIGURE 5.17 Selecting your favorite presets will streamline your workflow.

Custom Preset Library

FIGURE 5.18 Use the Custom Preset Library to access presets you've create.

The Custom Preset Library is where you access all the presets you've created (**FIGURE 5.18**). Notice that you have a few more options when managing your own presets, including updating, exporting, deleting, and of course adding presets. Keep in mind that these features are restricted to your presets only and are not accessible in the Preset Library or Imported Library. Let's look at these options in more detail:

- **Add Preset.** To add a preset, click the plus sign in the top-right corner. Name your preset and click Save. Keep in mind that presets will save all your adjustments without control point information.

- **Delete Preset.** Delete a preset by rolling your cursor over the preset. Click the X in the top-left corner to delete the preset.

- **Export Preset.** Export a preset by rolling your cursor over the preset. Then click the arrow in the top-right corner to export your preset. This is handy when you want to share a preset or back up a particular preset.

- **Update Preset.** You can update only custom and imported presets. Roll your cursor over the preset. Click the Update button in the bottom-right corner to update a preset to match your current filter settings. Keep in mind that any control points that have been applied to your current image will not be saved to the filter that you're updating. The reason is that presets are not image specific but instead are global in nature.

- **Export All.** Click the Export All button to create a backup or to share all of your custom presets.

Importing presets

Another great advantage of presets is that you can share them with fellow HEP2 users. Importing presets works similarly to adding your own preset. To import a preset, click the Add button in the top-right corner and then locate the preset files, which end with an .np extension.

You can import presets directly from Nik Software's site at www.niksoftware .com/presets or from a fellow HDR Efex Pro 2 user (**FIGURE 5.19**). You can delete and export a custom imported preset, but you cannot update it (review the Hot Tip below for a workaround).

FIGURE 5.19
Download a growing library of presets directly from the Nik Software site.

History browser

The History browser is very similar to all of Nik's History browsers with the exception of a few enhancements, such as the Merge Settings button, Default Tone Mapping, and Middle Exposure. I'll explain those features shortly, but let's first explore how to use the History browser.

The History browser is a chronological list of all the adjustments made to an image (**FIGURE 5.20**). It's a wonderful tool when you need to step back in time but don't want to undo everything you've created. I like to use the History browser to compare different stages (states) in my edits. By default, the History State Selector is positioned on Default Tone Mapping so that you are always comparing all edited states to the original tone mapped image. You can move this selector to any state along your edit timeline. Using the History State Selector, you can compare your current setting to any stage in the editing process and view those comparisons using Split Screen Preview, Side-by-Side Preview, or Single Image Preview when you click the Compare button. Let's take a deeper look at the History browser options:

- **Merge Settings.** Click this button if you ever notice any major problems with your image, such as ghosting, alignment, or chromatic aberrations. After clicking this button, you'll return to the Merge Dialog interface so you can make the appropriate adjustments.

- **Default Tone Mapping.** Select the Default Tone Mapping state to compare your current edits against your originally unedited tone mapped image.

- **Middle Exposure.** Select the Middle Exposure state to compare your current edits with your middle exposure from the Merge Dialog interface. This is a great tool to use when you want to compare your HDR image to a non-HDR frame from your series.

- **Last Filtered State.** The Last Filtered State button at the bottom of the History browser works much like a preset but instead processes your image using the exact enhancements used on your last image.

HISTORY BROWSER WARNING

The History browser is different than an Undo button in that if you decide to go back in time and make edits to a previous state, any edits that you've made from that point on will be wiped out.

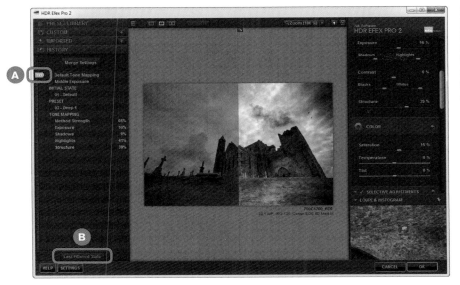

FIGURE 5.20 Use the History State Selector (A) to compare edits. Click the Last Filtered State button (B) to process your image using the same settings used on your last image.

Top Menu

Control how you view an image by using the basic controls at the top of the interface. Let's review these basic features from left to right (**FIGURE 5.21**).

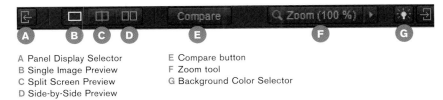

FIGURE 5.21
Adjust these settings to optimize your workspace.

A Panel Display Selector
B Single Image Preview
C Split Screen Preview
D Side-by-Side Preview

E Compare button
F Zoom tool
G Background Color Selector

Adjustment panel hide/show

Show or hide either the left or right panel by clicking the Panel Display Selector, or by pressing the Tab key to toggle between opening and closing both adjustment panels at once.

Image preview modes

Use Single Image Preview to view the entire image, or Split Screen Preview or Side-by-Side Preview to compare before and after results.

Compare button

The Compare button allows you to toggle between the newly edited image and state selected by the History State Selector. Keep in mind that the Compare button works only in Singe Image Preview mode.

Zoom tool

You'll really want to use the Zoom tool in HEP2 because merging images can cause some bizarre artifacts. After the merge, take a little extra time with the Zoom tool to make sure everything is lined up properly and to confirm that your image is artifact free (**FIGURE 5.22**). The Zoom tool is great for reviewing images and identifying potential problems, such as dust, noise, or halos. To activate this tool, click the magnifying glass or press the spacebar; the Navigator window appears, enabling you to pan around the image.

FIGURE 5.22 Use the Zoom tool to scan your image for any unwanted artifacts.

Background Color Selector

Use the Background Color Selector to adjust your screen's background to gray, black, or white. I prefer to use the default gray while I'm in HEP2 to maintain a neutral background, but you can set this according to your preference.

Right Panel Adjustments

The right panel is where you will do all your creative editing using the five adjustment panels: Tone Compression, Tonality, Color, Selective Adjustments, and Finishing (**FIGURE 5.23**). Each panel comes equipped with a set of unique tools to help you make creative adjustments. I recommend that you start your workflow with Tone Compression and work your way down to Finishing. However, some changes you make later in processing do require you to go back and tweak previous settings. I'll explain this further in the next few pages, but first let's explore these five adjustment panels and then work on an image together.

FIGURE 5.23 Select the adjustment to expand the available tools.

Tone Compression panel

The Tone Compression panel is the main panel where you'll control the overall HDR effect of your image. Whenever I use the Tone Compression panel, I like to have a specific goal in mind for my image. That goal may be to create a very realistic HDR image that leaves people guessing how I achieved the end effect, or I'll be very clear with my intention and deliver a very obvious and creative rendition of a scene. Whatever your goal is, keep it in mind as you manipulate the five Tone Compression panel sliders:

- **Tone Compression.** Use the Tone Compression slider to increase or decrease the dynamic range in the image. Its default setting is 0%, but as you move the slider to the right it will darken areas that were bright and lighten areas that were dark. Moving the slider to the left will decrease the dynamic range of an image and make it appear more like the middle exposure in a series (**FIGURE 5.24**).

- **Method Strength.** Use the Method Strength slider to fine-tune the amount of detail and drama that's applied to the image via the tone mapping algorithm. Move the slider to the right to increase detail and drama and to the left to decrease those effects. It might help you to think of detail and drama in terms of microcontrast, which is the contrast between two neighboring pixels with different brightness or color values. I've found it more effective to apply Method Strength via Control Points to allow for a more selective adjustment.

- **HDR Method.** The Depth, Detail, and Drama sliders are where all the real fun comes into play. Once again, when you're working with these sliders, it's helpful to have a vision in mind for your image. Do you want to create a very realistic or artistic image, or a blend of something in between? These three sliders are easy to work with and, best of all, deliver some very unique results.

- **Depth.** The Depth slider was created specifically for HEP2 and should be used whenever you want to add visual dimension to your image. The three depth options are Subtle, Normal, and Strong. Move the slider from the Off position and to the right to add depth to your image (**FIGURE 5.25**).

FIGURE 5.24
An example of decreased dynamic range (top) and increased dynamic range (bottom).

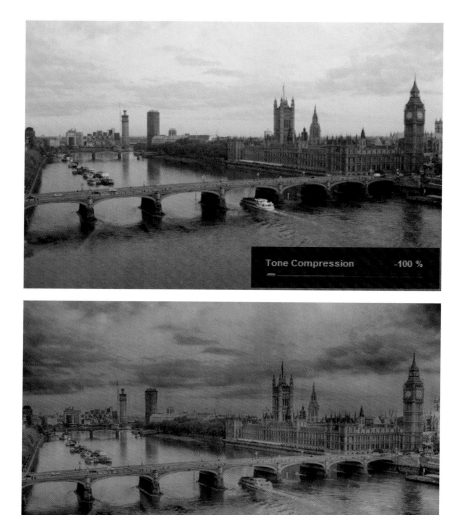

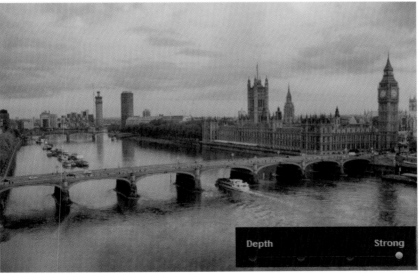

- **Details.** Use the Details slider to control how the tone mapping algorithm renders fine details. The five slider options are Soft, Realistic, Accentuated, Detailed, and Grungy (**FIGURE 5.26**). Move the slider to the right to accentuate detail in your image. The Realistic and Accentuated sliders provide the most natural-looking enhancements in details and sharpness.

FIGURE 5.26 Use the Detail slider to increase or reduce texture in an image. Reduce details or texture in an image with the Soft slider (top). Increase detail and sharpen an image while maintaining a natural appearance with the Accentuated slider (middle). Create a very stylized image by greatly accentuating fine and mid-level details using the Grungy slider (bottom).

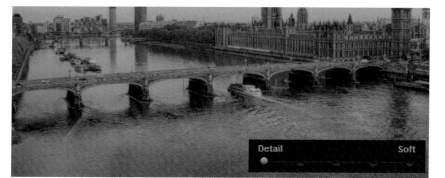

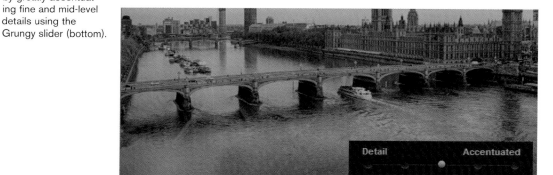

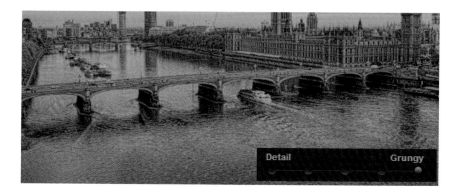

- **Drama.** The Drama slider is unique in that it takes advantage of the Drama algorithm, which is designed to increase contrast in areas based on tonality and color. Move the slider to the right to increase contrast using six presets: Flat, Natural, Deep, Dingy, Sharp, and Grainy (**FIGURE 5.27**).

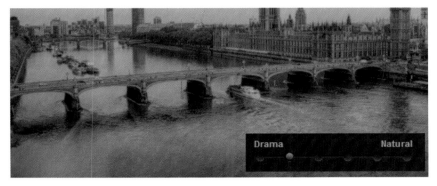

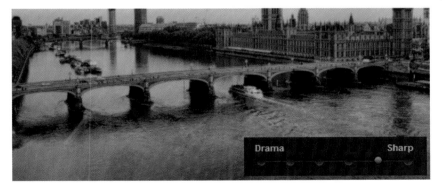

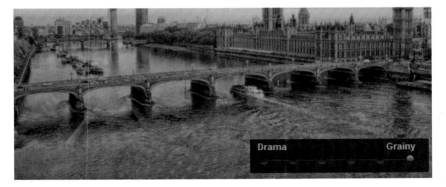

FIGURE 5.27
Use one of my three favorite presets to increase contrast between tones and colors. Use the Natural preset to create a more realistic tonal contrast (top). Use the Sharp preset to increase the whites and blacks in objects throughout the image (middle). Use the Grainy preset to greatly increase details between tones (bottom).

Tonality adjustment panel

Use the Tonality adjustments to make global adjustments to images using the Exposure, Contrast, and Structure sliders (**FIGURE 5.28**):

FIGURE 5.28 Use this slider to control an image's expsosure and contrast.

- **Exposure.** Move the Exposure slider to the right to increase the brightness of the image and to the left to decrease the brightness.

- **Shadows and Highlights.** Think of the Shadows and Highlights sliders as micro-tone mapping adjustments for your shadows and highlights. Moving the sliders to the right increases exposure, and moving the sliders to the left decreases exposure for those highlight and shadow tones.

- **Contrast.** Increase the global contrast of the image by moving the slider to the right, or decrease it by moving the slider to the left.

- **Blacks and Whites.** Use the Blacks and Whites sliders to increase the black and white points. The major difference between these sliders and the Shadows and Highlights sliders is how they affect the tonality of the image. The Shadows and Highlights sliders will adjust the exposure of all the shadows and highlights, thus changing the tonality of the image. However the Blacks and Whites sliders affect only the darkest and lightest tones of an image, thus allowing you to recover lost details in those regions.

HOT TIP

Activate highlights by pressing Alt+H (Option+H). Activate Shadows by pressing Alt+S (Option+S).

I recommend turning on Show Clipped Highlights and Shadows in the Loupe view so you can work the sliders to recover lost details (**FIGURE 5.29**). To activate it, roll your cursor over the Loupe view and click the box in the top left (Shadows) or top right (Highlights) to show clipped areas of the image.

FIGURE 5.29 Recover lost details in highlights and shadows using the Shadows or Highlights sliders in Loupe view.

- **Structure.** Move the Structure slider to the right to increase fine details or to the left to decrease them. Even though you try to make all of your white balance adjustments on the front end before the tone mapping,

you might still have an image that is too cool, too warm, or an unusual tint. Use the Temperature and Tint tools to address these problems with white balance or to create a unique effect.

Color panel

Use the Color adjustment panel to make global adjustments to Saturation, Temperature, and Tint (**FIGURE 5.30**):

- **Saturation.** Use the Saturation slider to control the strength of the color.

- **Temperature.** Move the Temperature slider to the left to cool the image temperature or to the right to warm the image.

FIGURE 5.30 When you're using the Color panel, make small adjustments to avoid oversaturating an image.

- **Tint.** Use the Tint slider to make adjustments to the green and magenta hues.

Selective Adjustments panel

Use the Selective Adjustments panel to make precision adjustments to your image using Control Points. Every Control Point is equipped with eight enhancement sliders to help you make adjustments to your image. Keep in mind that these eight sliders are created using the same concept as outlined in the previous three global adjustment sections: Tone Compression, Tonality, and Color (**FIGURE 5.31**).

FIGURE 5.31 Control Points give you surgical control over an image via eight precision adjustment sliders.

Finishing panel

The Finishing panel is designed to be one of the last stops you'll make before saving your image (**FIGURE 5.32**). It's here that you'll apply Vignettes, Graduated Neutral Density, and Levels and Curves adjustments. However, in many cases I'll make adjustments to the Neutral Density filter and the Tone Curve prior to making adjustments to Color or making any Selective Adjustments. The reason I do this is to avoid having to duplicate work. Making an adjustment to the Tone Curve or Neutral Density filter can affect the exposure

FIGURE 5.32 Don't be afraid to use some of these tools early in your editing stage.

of the image, so I like to make those adjustments prior to adjusting color, and especially before I start making any Selective Adjustments. Let's review the Finishing panel in more detail:

FIGURE 5.33 I like to apply lens or vignette presets toward the end of my editing process.

- **Vignette.** A vignette is used to draw attention to a particular area of focus. You have the ability to create a vignette automatically by using any one of the eight lens presets (**FIGURE 5.33**). Or you can make manual adjustments by selecting the Detail's Twirler (the triangle to the left of the word Vignette) to access the Amount, Circle, Rectangle, and Size sliders, and the Place Center button. Each of these sliders allow you additional control over the vignette. For the best results, start with a preset and make manual adjustments from there.

- **Graduated Neutral Density.** The Graduated Neutral Density filter alone makes HEP2 essential for any landscape photographer (**FIGURE 5.34**). Use this feature to make adjustments to the brightness of the upper or lower tones of an image. This is very similar to the Graduated Filter feature in Lightroom, Photoshop, and Aperture, but it is so much better because it's HDR, baby! That's right, you can actually harness the true power of HDR by making incremental adjustments to the exposure. It creates such a natural look and feel when blended appropriately that in many cases it's hard to tell the difference between the filter and reality.

FIGURE 5.34 Use Neutral Density filters early in the editing process, especially when you're dealing with a dark foreground and a light background.

- **Levels and Curves.** I rarely use Levels and Curves in any of Nik's plugins, but HEP2 is the exception. Nik has done a great job of creating eight very unique and realistic Curve presets. I'm a huge fan of the Film series and the realistic tones it creates. As always, I recommend starting with a preset and making adjustments as needed to meet your personal vision (**FIGURE 5.35**).

FIGURE 5.35 The Film presets are some of my favorites and are an easy way to get started with the Tone Curve adjustments.

HDR:
The Golden Hour Enhancer

Now that you've learned all the components of HEP2, it's a good time to put it to some practical use. One of my favorite times to use HDR is when light is just beginning to enter a scene or quickly fleeting, which is known as the golden hour. Nature does a beautiful job of creating a dynamic light show that is difficult to reproduce in the camera without some processing assistance. Recently, at my Death Valley workshop, I had the pleasure of witnessing a gorgeous sunrise at Zabriskie Point. The striations in the rocks mixed with a colorful background seemed perfect for an HDR exposure, so I decided to auto-bracket the exposure at -2, 0, +2. My goal was to enhance the image, adding contrast and vibrance, by harnessing the dynamic range. Keeping that goal in mind, let's process these images together.

1. Be sure to register your book so you can download the three images you'll use in this exercise: HDR -2.tif, HDR 0.tif, and HDR +2.tif.

2. Export the images into HDR Efex Pro using your host program, such as Lightroom, Photoshop, or Aperture.

3. With all three images in the Merge Dialog interface (**FIGURE 5.36**), you'll start by making adjustments to minimize ghosting and chromatic aberrations.

4. Select an image for the Ghost Reference. Upon inspection, there was very little movement captured between the three frames, so choose a low Ghost Reduction Strength of 40%.

5. Use the Magnifying tool to assess for any chromatic aberrations, and if there are any, take note of the color. You should see some chromatic aberrations in the mountain ridges, so reduce the Red-Cyan slider to -8. Make adjustments to the sliders until color aberrations are no longer visible or at least very minimal. When you're finished, click Create HDR; the image will complete its merger and launch HDR Efex Pro's native interface.

FIGURE 5.36 Select a Ghost Reference image that has very little movement, and then choose a Ghost Reduction Strength of 40%. Reduce Chromatic Aberrations by sliding the Red-Cyan slider to -8. Click Create HDR when you're finished to complete the merger and launch the interface.

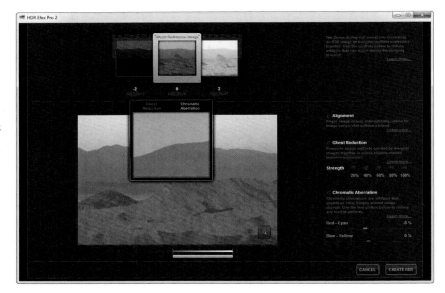

6. Select a preset that best represents your vision for this image. As mentioned earlier, the goal is to enhance the tonal range of this image and create a natural increase in colors while simultaneously adding contrast. Try selecting the Bright preset to help you get started (**FIGURE 5.37**).

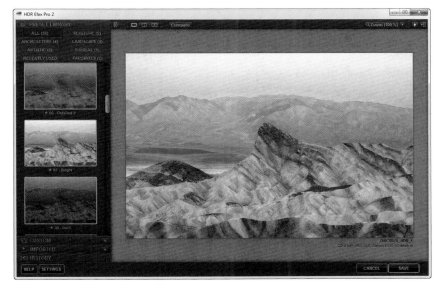

FIGURE 5.37
Select a preset that best fits your vision. Here I've selected the Bright preset.

7. After you've chosen the preset, close the left panel by clicking the Hide adjustment panel icon in the top-left corner.

 Now you can focus on the image and adjustments without the distractions of the presets.

8. Review the Tone Compression first. Remember that the more Tone Compression you add, the more unnatural the image will look, so start by reducing the Tone Compression slider to 33%. At the same time, increase the Method Strength slider to increase the amount of detail in the image. The preset has done a nice job of selecting the appropriate HDR Method sliders, so you can leave these settings alone (**FIGURE 5.38**).

FIGURE 5.38 The Tone Compression panel controls how real or surreal you want your image to look.

9. Move on to the Tonality adjustments to make a subtle increase in the Contrast slider by moving it to 15%. This gives the image the punch it needs and adds a realistic amount of contrast (**FIGURE 5.39**). My preference is to create subtle HDR edits to avoid being too obvious while still pleasing to the eye.

10. The Color panel is another area where color saturation can go awry very quickly, so once again make subtle changes to these three sliders. Move the Saturation slider up to 15% and warm up the image a bit by moving the Temperature slider to 14% (**FIGURE 5.40**). These are the edits that I find to be the most visually pleasing on my screen, but while you're processing these images, feel free to experiment beyond my numerical suggestions.

FIGURE 5.39 Use the Tonality panel to control the exposure and contrast in an image.

FIGURE 5.40 Small adjustments to the Color panel can make huge improvements to an image.

HOT TIP

When you're working an image, I always recommend getting feedback from others. My goal is to create a dynamic image that has a natural look, so getting feedback while I'm working in the Tone Compression and Color panels is critical to help me achieve that goal.

11. Now you'll use Control Points and make precision adjustments to areas of the image that still need attention. I like to use Control Points to help make simple dodging and burning adjustments (**FIGURE 5.41**). In this case select the background and darken it just a tad to help offset it from the foreground. Next, select one of the darker striations in the rock and increase the black a tad to help burn in the lines in the rock. Then select a lighter striation in the rock and increase the White slider to help add contrast to the rock.

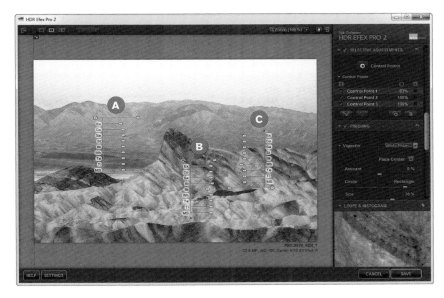

FIGURE 5.41 Use Control Points to help highlight portions of an image. Select the background and darken it (A); select one of the darker striations in the rock and increase the black (B); select a lighter striation in the rock and increase the White slider (C).

12. Let's darken the sky and lighten the foreground using the Graduated Neutral Density feature. Decrease the Upper Tonality slider by -0.5 stops, thus darkening the sky. To lighten the foreground, increase the Lower Tonality slider to 0.25 stops (**FIGURE 5.42**). Skip the Tone Curve adjustment because it was set by the preset, which appears to have done a nice job by placing a gentle S-curve in the Tone Curve.

FIGURE 5.42 The Graduated Neutral Density panel is a wonderful landscape tool that gets used in almost all my images.

Let's look back to where you started with the three bracketed images and where you finally ended up with the final HDR image (**FIGURE 5.43**). As you can see, the image pops off the screen, and you've done a nice job of harnessing the dynamic range of the image.

FIGURE 5.43
By combining three raw images, you're able to harness the power of dynamic range and create a more compelling image.

Top Ten Tips for Shooting HDR

Here are my top ten tips for creating a stronger foundation for shooting and processing an HDR image:

1. Shoot in RAW. RAW provides the highest dynamic range and the best quality file for an HDR merge.

2. Avoid noise. HDR really accentuates noise, so try to avoid noise at all costs. Keep your ISO as low as possible and avoid sharpening. If noise is present, use Dfine or your RAW converter to reduce noise before exporting into HEP2.

3. Use a tripod with a cable release to avoid camera shake.

4. Check your system requirements. Two gigabytes of RAM is the minimum requirement, but 4 GB or more is recommended. You can never have enough RAM when creating HDR images.

5. Become a storm chaser. HDR loves the dramatic light created immediately prior to or following a weather event.

6. Set your camera lens to manual focus after using the autofocus to avoid any focus creep. Also, use manual exposure (if you're comfortable) or at the very least use Aperture Priority, so your depth of field won't change between frames.

7. Use your camera's histogram to make sure you're bracketing the exposure properly. Three images at two stops apart or five images at one stop a part will be sufficient for most scenes. Interior shots might require bracketing five exposures (-2, -1, 0, +1, +2) or more depending on the complexity of the lighting.

8. Be creative but not obvious. Use HDR to enhance your image but don't overdo it. Keeping an image simple and elegant is the key to creating an effect that will stand the test of time.

9. Create a stunning black and white image. HDR isn't always about making color look great. Some of the most interesting black and white images have been created using HDR. A quick way to get there is to slide the Saturation slider to 0 and voilà, instant B&W conversion!

10. Use tags, labels, keywords, and collections to help manage your HDR image library.

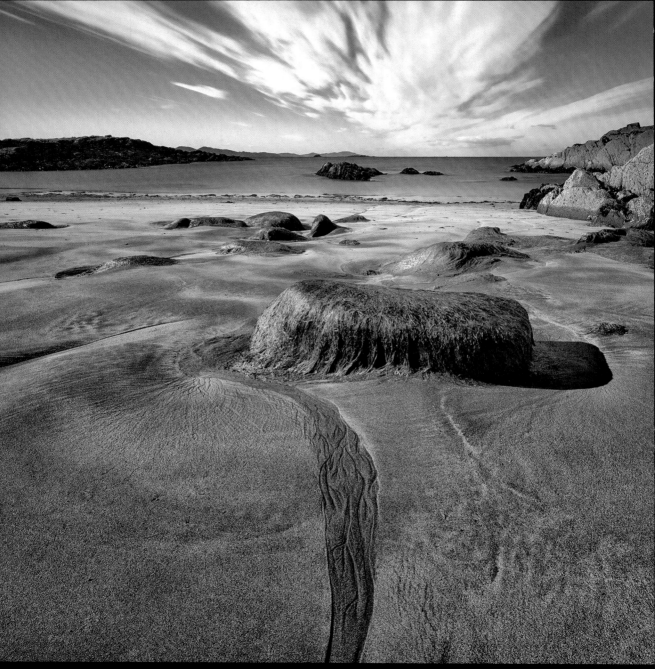

"Coast of Ireland," Ring of Kerry, Ireland, 2012

Canon 5D Mark II 35mm 3 @ f/12 ISO 100

Chapter 6

SHARPENER PRO 3

How often have you been in a gallery staring at another photographer's work and said to yourself, "Wow, this person's images are super sharp! My images never look that good when I print them." I don't know about you, but I remember the first time it happened to me. That's when I decided to learn more about how to create a sharper image. I had no idea how important sharpening was in creating a dynamic image. Most photographers know that a crisp image starts with a solid foundation, including decent equipment, proper exposure, and focus. But even when you have a solid foundation, you still need to apply some sharpening to take your images to the next level.

Creating a perfect print or crisp online image is every bit the art form as taking a stunning image. In the following pages you'll explore why you need to sharpen your images and how best to integrate Sharpener Pro into your workflow.

Sharpener Pro's Two Filters

Sharpener Pro 3 consists of two unique filters: RAW Presharpener, which is the first step in the sharpening process and takes place prior to any other image edits, and Output Sharpener, which applies sharpening prior to printing, sharing, or displaying your image. One of the key differences between the two filters (other than their sequence in the editing process) is the overall strength of sharpening. Generally speaking, RAW Presharpener is used to apply a gentler amount of sharpening at the beginning of the workflow, and Output Sharpener is used to apply a comparatively stronger amount of sharpening at the end of the workflow.

One major decision you need to make is whether or not you need to sharpen your image twice. Only in very special circumstances when I need complete control over the image do I sharpen it twice. Otherwise, I focus on sharpening my image only once at the very end of the process using the Output Sharpener. But before you make your own decision, let's review why it's necessary to sharpen your images.

Why Sharpen an Image?

In a nutshell, most people have grown accustomed to expecting images to be tack sharp because today's technology makes it more possible than ever. Creating a sharp image is at the top of many of my students' priority lists. They always want to know how to produce those super crisp images that they're used to seeing in magazines and galleries (**FIGURE 6.1**). The reality is that it starts with a good capture in the camera and ends with effective sharpening in postprocessing. Remember that no sharpening software, regardless of which one you choose, will ever repair a very blurry image unless you want a severe-looking blurry image!

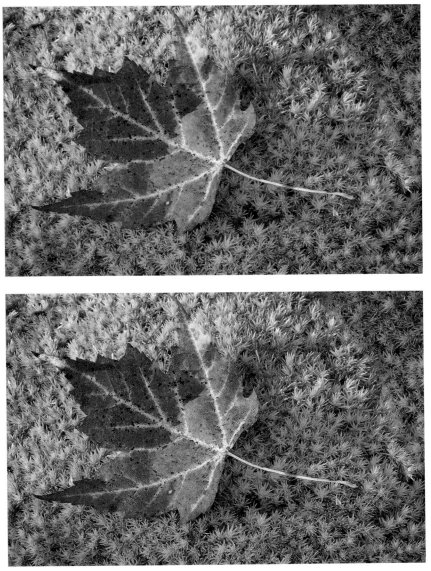

FIGURE 6.1 Compare the before (top) and after (bottom) sharpening effect on this image. The sharpened image really brings out the details.

How Your Camera Affects Sharpness

Much like the human eye, a camera lens is very sharp toward the center of the lens and begins to lose detail toward the edges. Even the most expensive and highest-quality prime lenses suffer this fate, but to a much lesser degree than their inexpensive zoom counterparts. Some loss of detail is inevitable regardless of equipment, but the quality of the lens plays a large role in how much you have to sharpen your images in postprocessing.

Beyond your lens, most camera sensors have a filter added to them to reduce moiré patterns that can occur in areas of detail, like a particular weave or pattern in a shirt (**FIGURE 6.2**). These low-pass filters are used to create a slight blurring effect so the sensor doesn't create a moiré. Because of this feature, sharpening should be applied to overcome this slight blur.

FIGURE 6.2 The image on the left has a moiré pattern; the image on the right does not.

JPEG vs. Raw

If you shoot using the JPEG file format, your camera will apply sharpening to the image as it generates the file, and the sharpening will be permanent. That's yet another reason I encourage photographers to shoot in raw. With a raw image format, you can selectively control the sharpening during the raw conversion, whether you control it using the RAW Presharpener filter or another raw conversion tool like Adobe Camera RAW in Adobe Lightroom (**FIGURE 6.3**). I'll go into more detail on this later in the chapter.

FIGURE 6.3 Lightroom's default presharpening setting.

Why Sharpen for Output?

The maddening but also fun part of being a photographer is that it's no longer just good enough to get everything right at capture. Nowadays, photographers need to be print masters who are well versed on the best practices and techniques for preparing images for presentation.

Social media and online portfolios have made sharpening for screen display more important than ever (**FIGURE 6.4**). However, most people don't realize that every time you resize an image, you lose a little detail. For that reason, it's essential to resize your image accordingly and apply sharpening before sharing your image online or in presentation.

FIGURE 6.4
I resize and sharpen all my images before uploading them to my portfolio.

The qualities of printers available to photographers today are simply amazing, and when you properly sharpen an image, the print quality can be outstanding! But remember that anytime you print on paper, you must compensate for some softness in your final printed image due to the nature of how ink is absorbed. With all things equal, glossy or luster paper will be sharper than matte paper simply because of how the ink is absorbed. Sharpening your image for output based on printing technique, size of image, and paper is a critical step to producing an excellent print.

Outsourcing your printing needs to a photo lab might require you to do some sharpening, but be sure to contact your printer and ask about its requirements first. Some labs will request that you don't apply any sharpening because people have a tendency to oversharpen their images. So contact your lab to see

if it wants to receive the file with or without sharpening. Also, if your lab does allow or even request that you sharpen your image, you need to make sure you have a clear understanding of its printing process before you sharpen your image. More on this critical step is discussed later in this chapter.

One of the great benefits of taking control of your own printing process is the ability to marry your images from printer to paper while applying creative sharpening techniques that make your images look and feel unique. The ultimate goal of many photographers is to create images in their own distinctive style and sharpening is an important part of this process.

Sharpening Pro 3 Workflow

Typically sharpening is applied only twice during your workflow: once in the beginning before doing any image edits, and once at the very end of post-processing before outputting your image online or in print. My recommendation is to focus on sharpening at the end of your workflow using the Output Sharpener unless you have a very special image in which you need to control the sharpening from beginning to end.

The reason I recommend this approach is twofold: If you're a JPEG shooter, there's no need to apply sharpening in the beginning because your camera has already done this for you. If you're a raw shooter, the raw converter software will have applied some amount of sharpening during the conversion process.

I rarely use the RAW Presharpener filter because most raw conversion applications do an adequate job of sharpening the image after capture. Keep in mind that this is one of Nik's oldest plugins, and even though it's been updated regularly to meet the needs of today's users, it certainly has some legacy tools, like the RAW Presharpener, that are becoming obsolete given the huge advances in sensor and raw conversion technologies.

However, there are times when you might want to use Nik's RAW Presharpener exclusively because of the ability it provides you to isolate exactly the areas of a raw image that need presharpening, which you can't do in Lightroom or Apple Aperture. Even if you don't plan on using the RAW Presharpener filter, it's a good idea to continue reading the next few sections because they will help you understand more about sharpening. One great aspect of this plugin is that the two filter interfaces are very similar, so you won't waste your time learning about the one you may not use often.

Preparing Your Image
for Presharpening

Before you begin presharpening a raw image, you need to complete a couple of tasks. First, you need to make sure sharpening is turned off in your raw converter prior to using the RAW Presharpener filter. To do this, locate the Sharpening setting in your raw conversion software, whether it is Adobe Camera RAW, Lightroom, Aperture, Capture Nx2, or Canon Digital Photo Pro, just to name a few (**FIGURE 6.5**).

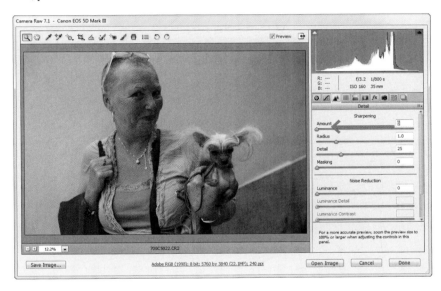

FIGURE 6.5 Be sure to turn off all sharpening before you edit in the RAW Presharpener.

Second, you need to evaluate whether or not your image needs any noise reduction. If your image has noise, it's best to tackle it now before sharpening it unless you want to draw more attention to the noise! Review Chapter 1, "Dfine 2.0," if you need a refresher on noise reduction.

> **HOT TIP**
>
> Turn off camera sharpening to reduce the chance of oversharpening your image. Also, consider creating a "no sharpening" preset to turn off sharpening in one easy step. You can download my Lightroom preset at www.johnbatdorff.com/pluginwithnik.

Then launch the RAW Presharpener to begin the sharpening process.

The RAW Presharpener's default view (**FIGURE 6.6**) displays the image with the Preview box selected while in Sharpened Image mode. The interface layout and operation is very similar to Nik's noise reduction application Dfine. If you're familiar with Dfine, you'll find this filter very intuitive. The Split Preview allows you to review the before and after effects of the filter as you move the "split line" across the screen.

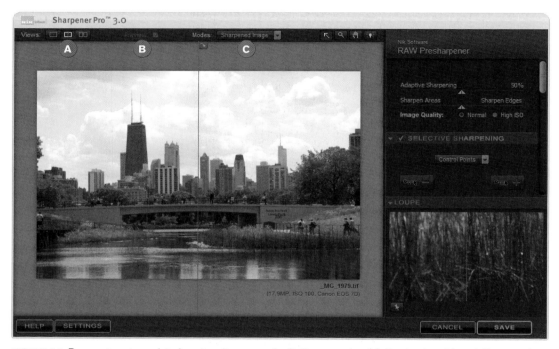

FIGURE 6.6 Be sure to set your interface to suit your needs: Split screen view (a), Preview box (b), and Sharpened Image mode (c).

Split Preview helps me assess the image to determine how and where I'll apply sharpening. It also helps me avoid the number one pitfall most photographers make and that is to apply too much sharpening. Presharpening is about applying a little bit of sharpening—just enough to bring detail back into areas that might appear soft (**FIGURE 6.7**). In most cases, I simply use the filter's default value and focus on manipulating the Edge Balance slider (discussed in the next section). This is a personal preference but also best practice when you're using the RAW Presharpener to avoid going down the technology rabbit hole by applying too many adjustments. Instead, leave the real fine-tuning to the Output Sharpener filter.

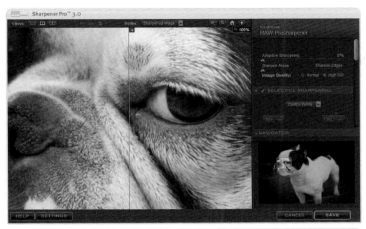

FIGURE 6.7 Notice the slight difference between an image that has been properly pre-sharpened and one that has been oversharpened.

Zero presharpening

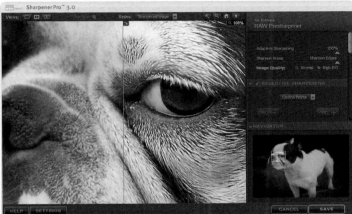

Overly presharpened

Properly presharpened

RAW Presharpener Global Tools

Use the following global tools to apply the RAW Presharpener filter to the entire image:

- Adaptive Sharpening strength (**FIGURE 6.8**) controls how much sharpening is applied to the image. The default value is set at 50%, and although this works well most of the time, you may need to increase or decrease sharpening as desired. Keep in mind that this is a global adjustment and affects your entire image.

FIGURE 6.8 Make all of your global sharpening adjustments in the RAW Presharpener dialog box.

- The Sharpen Areas and Sharpen Edges slider controls the amount of sharpening that is applied either at the edges or between the edges of an object. The default position is 50% and applies sharpening equally between the edges and the areas. Move the slider toward Sharpen Area to increase the sharpening applied between the edges of an object. Adjust the slider toward Sharpen Edges to increase the sharpness of the edges while reducing sharpening applied to an area in between the edges (**FIGURE 6.9**). In most cases you'll want to sharpen toward the edges because sharpening at the edges of an object will appear more natural to the viewer's eye.

FIGURE 6.9 Move the slider to the right to increase the sharpness of edges, such as hair.

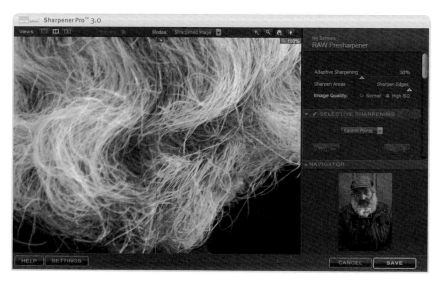

- Image Quality controls and helps avoid the creation of additional noise as a result of the sharpening process, so be sure to select the appropriate option. (The dark circle indicates the option has been selected!) ISO and noise technology have come a long way since this feature was first introduced, so you may be wondering what's considered a high ISO in today's world. I generally select High ISO for any image that I shot over 2000 ISO. You'll need to know your equipment's limits, but this is a good starting point. With that said, I rarely sharpen High ISO images simply because doing so tends to accentuate the noise and any artifacts that might exist as a result of the High ISO capture.

Selective Sharpening Tools

Selective Sharpening is where you'll see the real benefit of presharpening (**FIGURE 6.10**). It's in this feature set that you're able to identify specific areas where you want to increase or decrease sharpening. You should increase presharpening in areas where you want to accentuate detail and decrease sharpening in areas where you want to avoid detail. Imagine a lone sunflower against a blue sky: You would increase the sharpening in the sunflower to help bring out the detail but decrease sharpening in the sky to avoid highlighting unwanted details, such as noise. This process is very similar to the workflow in Dfine because it uses Control Points or Color Ranges to help identify specific areas of an image to apply the filter's effect.

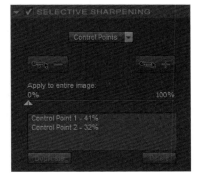

FIGURE 6.10 Use Selective Sharpening to apply the RAW Presharpener filter to specific regions of your image.

How I use Nik's RAW Presharpener

Typically, I'll use the RAW Presharpener filter on some of my HDR shots to control the areas that receive sharpening. My favorite Selective Sharpening tool is Control Points because they allow me to turn the filter on or off, and control the strength the filter's effect.

Control Points

You can learn more about Control Points by registering your book and downloading the Chicago Skyline.tif file at www.peachpit.com/nikplugin. When you have the image open in the RAW Presharpener, follow these steps:

1. Set your desired level of sharpening using the Adaptive Sharpening and Edge Balance sliders.

2. Select the appropriate Image Quality setting.

3. Place a positive Control Point on an area where you want to apply sharpening. Remember that positive control points add sharpening and negative control points remove sharpening.

4. Click Modes and choose Effect Overlay (**FIGURE 6.11**) so you can see where the sharpening is being applied. In this mode the areas receiving the sharpening are painted red.

5. Continue placing positive control points on areas where you want to presharpen, such as the buildings, the bridge, and the trees.

FIGURE 6.11 Use the Effect Overlay to help pinpoint the regions of your image that you want to presharpen.

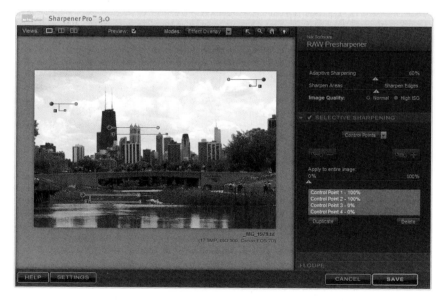

6. Drop negative control points on areas where you don't want any sharpening applied. You should already have applied noise reduction prior to using the RAW Presharpener, but even after noise reduction has been applied, sometimes sharpening can draw attention to unwanted details. You can mitigate this problem by dropping a negative control point in areas that don't need sharpening.

Effect Mask

Another handy way to identify the areas being affected is to change Modes to Effect Mask (**FIGURE 6.12**). The areas in black receive no sharpening, and the areas in white and gray receive sharpening. Use this Effect Mask mode to assist in cleaning up your mask. At this stage, you may want to adjust the opacity of any of the control points by moving the sliders left to decrease or right to increase the filter's effect.

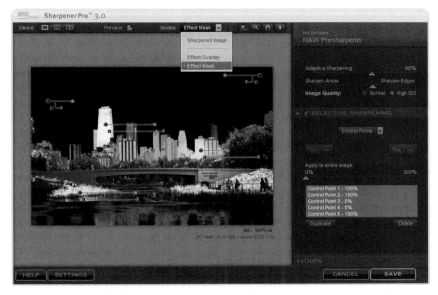

FIGURE 6.12
Use the Effect Mask mode to view the area being affected by the control points.

When you've completed all of your sharpening, return to the default Sharpened Image mode to review the image one last time before saving it.

After saving the image, you can continue processing the image in Photoshop or your favorite host application until it's time to apply the Output Sharpener filter.

Presharpening with Color Ranges

Color Ranges is another handy tool for selectively presharpening images based upon a color selection. This technique works well when you're trying to keep the sharpening consistent within a color range or if you have a large object that is one color. Start by setting your preferred level of sharpening using the Adaptive Sharpening and Edge Balance sliders (**FIGURE 6.13**).

FIGURE 6.13 Start selectively presharpening by adjusting your Sharpening sliders.

Next, select Color Ranges under the drop-down menu in the right panel (**FIGURE 6.14**). Using the eyedropper, select a minimum of two colors where you want to selectively apply sharpening. Keep in mind that you can add as many colors as you want, but two colors are the minimum requirement. In this image of radishes, I selected several shades of red to apply sharpening and adjusted the Opacity slider to take creative control over what shades received the most sharpening. Then I selected colors I didn't want to receive any sharpening by clicking the Add button, selecting the colors (in this case, green), and moving the Opacity slider to zero.

FIGURE 6.14 Use the eyedropper and Opacity slider to selectively apply sharpening to an image.

After you've placed the eyedropper, use the Effect Mask mode to verify that you have selected the correct colors to receive sharpening. Once again, remember to return to the default Sharpened Image mode to review your image before saving it.

Is presharpening worth the extra work?

The RAW Presharpener filter can be an effective tool if used sparingly and as part of the creative process. However, it is not recommended for the casual user. If you'll be sharpening an image only once, I recommend putting the time and effort into using Nik's Output Sharpener filter because it will deliver a bigger "wow factor" for the time and energy spent.

Output Sharpener Filter

Nik's Output Sharpener should be the last filter you use in the Nik suite prior to sharing your images and should be applied at the very end of the postprocessing stage. If you'll be applying sharpening only once during your workflow, this is the time to do it. This filter allows you to sharpen your image based on how you plan to share your work: online, via your own printer, or via an outside professional printer. You have several creative sharpening options that allow you to take control of your image and apply sharpening with your creative intent in mind. Sharpening and Clint Eastwood definitely have "the good, the bad, and the ugly" in common (**FIGURE 6.15**). I recommend sharpening your image to the point that it looks too sharp and then backing off just a tad to give it a more natural appearance. Of course, the amount of sharpening is subjective, but in general, if it's not intentional, it needs to be avoided.

FIGURE 6.15
No sharpening has
been applied (top).
Too much sharpening
has been applied
(middle). The correct
amount of sharpening
has been applied
(bottom).

Preparing Your Image

It is important to resize your image for the correct output size prior to applying sharpening. In Photoshop you achieve this by altering the image size (**FIGURE 6.16**).

FIGURE 6.16 Resize your image prior to sharpening.

Aperture and Lightroom users don't need to change the size of the image prior to sharpening, but instead should turn on the Image Size sliders (**FIGURE 6.17**) in the Output Sharpening settings. This will add Image Width and Image Height sliders to the bottom of all the Output Device settings with the exception of Display. The Image Width and Image Height sliders should mirror the intended print size to avoid poor sharpening.

FIGURE 6.17 Once enabled, mirror the Image Width and Image Height sliders to the intended output size.

With the image sized correctly or the settings configured correctly, you can now configure the Output Sharpener filter (**FIGURE 6.18**). Keep in mind that it works similarly to the RAW Presharpener filter.

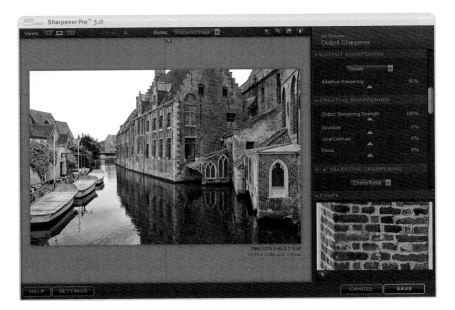

FIGURE 6.18 Select the proper output format prior to applying sharpening.

Display Sharpening

In today's world of online sharing, Display Sharpening will probably be the most often-used setting for many of you. Use this setting when you're sharpening an image for displaying online, viewing on a tablet, or using for presentation. Use the Adaptive Sharpening slider (**FIGURE 6.19**) to increase or decrease sharpening as needed.

FIGURE 6.19 Use the Display Sharpening setting for online sharing and multimedia presentations.

HOT TIP

Sharpening can be as addictive as the Vibrance slider in Lightroom, but to maintain a natural or realistic feel, try to avoid oversharpening your image.

Inkjet

Use the Inkjet setting if you plan on printing on an inkjet printer (**FIGURE 6.20**). Most of you who print at home or at the office will be printing on an Epson, Canon, or HP inkjet.

Viewing Distance and its menu settings allow you to control how much sharpening will be applied based on known distances or via the Auto setting. The Auto setting is recommended for most viewing situations and utilizes diagonal image size as the default viewing distance. You should change this setting only if you know the viewer will be significantly closer or farther away than the diagonal measurement of your image.

Paper Type allows you to control how sharpening is applied based on your paper type. As mentioned earlier in this chapter, all papers absorb ink differently. Textured and fine art paper absorbs more ink, resulting in dot gain, which creates a larger ink dot and less sharpness. Glossy paper absorbs much less ink and has less dot gain than a fiber paper, so the image will require less sharpening. Most of the papers are very easily identifiable, but confusion can exist between luster and glossy, so be sure to check which paper you're using before making the Paper Type selection.

Printer Resolution and its menu options should match the intended resolution for how the print will be made as indicated by the Print dialog box (**FIGURE 6.21**). Refer to your printer's owner's manual if you're not sure which resolution to choose. If your printer's resolution is not shown in the drop-down list, you can create a user-defined resolution by selecting Empty next to the User Defined option. Then type in the horizontal (larger number) and vertical resolution (smaller number).

HOT TIP

When you're selecting a print resolution, I recommend running tests on the desired paper at different resolutions to determine the best settings for viewing the image.

FIGURE 6.20 Use the Inkjet setting if you intend to do your own printing.

FIGURE 6.21 Be sure to match your printer's resolution to the filter's setting.

Continuous Tone

Use the Continuous Tone setting when you're sending your work to an outside printing service. The Viewing Distance option works the same as discussed earlier in the Inkjet menu. The only new setting you need to be concerned with is Printer Resolution. I recommend contacting your outside printing source for the appropriate DPI (dots per inch) settings (**FIGURE 6.22**). Many of the standard DPIs are listed in the drop-down menu. However, if your printer's recommended DPI is not listed, you'll need to create a new user-defined DPI by selecting Empty next to the User Defined option and typing in the appropriate DPI.

FIGURE 6.22 Confirm with your printer which DPI setting you should use.

Halftone

Working in the newspaper business for years, I can tell you that I've seen my share of halftones needing sharpening (**FIGURE 6.23**). My guess is that many of you will never use the Halftone option, but for those of you who plan on having your work printed in a newspaper, magazine, or book service such as Blurb, this option is for you. Viewing Distance works as described earlier, and the Auto setting should be sufficient. Select one of four Paper Type options from the drop-down menu: Newsprint receives the most sharpening, and High Gloss receives the least. Printer Resolution should be set according to the printer's guidelines. If you're unsure, contact the printer and inquire into what LPI (lines per inch) setting is used on the presses where your work will be printed.

FIGURE 6.23 Use the Halftone setting when your images will appear in a newspaper or book.

Hybrid Device

The Hybrid Device setting (**FIGURE 6.24**) is for printers that use a hybrid of inkjet and halftone techniques. Frankly, I have yet to find a need for this setting, so I'd avoid using this setting unless you know for a fact that the printer is using this device.

Creative Global Sharpening

After you've selected the appropriate output device, you'll want to head to the Creative Sharpening panel (**FIGURE 6.25**), where the real fun begins. It's in this panel that you'll learn how to use the four unique sharpening sliders in a creative manner. Sharpening adjustments made in this panel are global in nature and thus affect the entire image. Let's explore how each of these global sharpening sliders works.

FIGURE 6.24 Use the Hybrid Device setting when you're preparing your image for output to a hybrid device.

FIGURE 6.25 Use any of the four unique global sharpening sliders to add dimension to your image.

Output Sharpening Strength

Use the Output Sharpening Strength slider to control the overall sharpness of an image. Moving the slider to the right increases sharpening, and moving it to the left decreases sharpening. I recommend using the default value of 100%, adjusting the other three sliders, and then revisiting this slider one last time before saving the image.

Structure

The Structure slider is one of my favorites, and its unique algorithm does a great job of bringing textures and fine details to life. My approach to using the Structure slider with sharpening is very similar to how I outlined its use in Chapter 4. Think of this slider as an artist's paintbrush that allows you create

a signature feel. Increase structure in areas that have texture, like an old barn, but avoid adding structure to smooth tones, like a person's face or blue sky.

Local Contrast

Use the Local Contrast slider to increase the definition in edges and the shape of objects, but use it sparingly to avoid creating halos. Decreasing this slider will have the opposite effect and create a soft, diffused look (**FIGURE 6.26**).

FIGURE 6.26 Avoid halos by using the Local Contrast slider judiciously.

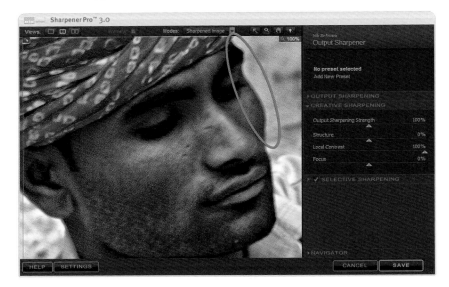

Focus

Although nothing will make a very blurry image appear in focus, the Focus slider applies adaptive sharpening to fine details in large areas of an image. Move the slider to the right to help deal with out-of-focus images due to a shallow depth of field. Conversely, move the slider to the left to make your image appear blurry.

Selective Sharpening

As with presharpening, you use Creative Sharpening when you want to apply sharpening to an entire image. But what if you want to apply sharpening differently to select regions of an image? That's when you advance to the Selective

Sharpening panel, where you can control how sharpening is applied throughout the image using the Control Points or Color Range tools. Selective Sharpening allows you to pinpoint where you want sharpening applied, whether it is on a particular area of an image or color. Let's explore Selective Sharpening a little further.

Control Points

Control Points work the same way as in the RAW Presharpener filter.

1. Click the Add Control Point button and position the control point using the Loupe view (**FIGURE 6.27**).

2. Define the region that you want to affect by using the top slider of the control point. In this case, to enhance the reflection in the water of the building, you need to create a large enough boundary to encompass the entire reflection. You can use any of the Control Point's four sliders— Output Sharpening Strength, Structure, Local Contrast, and Focus—to creatively affect the particular region of an image. If you don't see all the sliders, click the triangle beneath Output Sharpening Strength to reveal the other three sliders.

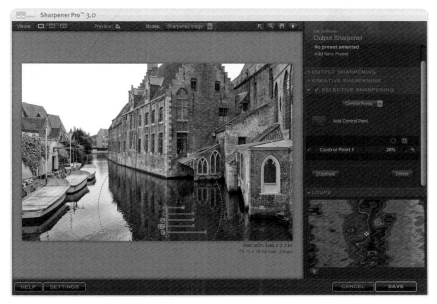

FIGURE 6.27
Use Control Points to selectively apply sharpening througout an image.

Keep in mind that by default any adjustments you make with Control Points will supersede any of the global Creative Sharpening adjustments. You can change this setting so global Creative Sharpening adjustments are unchanged when a control point is placed. I recommend using the default, but if you want to change it, click the Settings button on the bottom left of the Sharpener Pro interface.

3. Click Output Sharpening Settings, click the Default Control Point Settings drop-down menu, and choose Retain Creative Sharpening Settings (**FIGURE 6.28**). The default setting on the control point will then mirror that of the Creative Sharpening settings.

FIGURE 6.28
It's possible to retain Creative Sharpening settings by changing your preferences.

U-POINT TECHNOLOGY

Control Points use U-Point technology to analyze color, tone, detail, and location. This technology really goes to the heart of what makes Nik Software so great by providing you with the ability to pinpoint the exact pixels that you want to control. To learn more about how U-Point technology works, refer to the Introduction at the beginning of this book.

Color Ranges

I rarely use the Color Ranges tools for sharpening, but Selective Sharpening via Color Range works best when you're trying to isolate a handful of colors that compose a large part of an image, or if you're trying to batch process images with similar color and sharpening needs. To sharpen an image using Color Ranges, follow these steps:

1. Make all your Creative Sharpening adjustments. Remember that these adjustments will be applied globally to all colors.

2. Use the eyedropper to select colors you want to sharpen. In **FIGURE 6.29** I've selected the yellow door and the blue door.

3. Using the Output Sharpening Strength sliders, you can increase or decrease the effects of the Creative Sharpening settings.

4. To add another color, click the plus (+) sign. As with presharpening, you must select a minimum of two colors, but there is no cap on the number of colors you can add.

FIGURE 6.29 Color Ranges works well when you're working with a handful of colors or one dominant color.

"Mesquite Flats," Death Valley, USA, 2012

Canon Mark III 15mm 1/640 @ f/7.1 ISO 250

Chapter 7

ADVANCED TECHNIQUES IN PHOTOSHOP

There are many benefits of incorporating Nik's software into an Adobe Photoshop environment, and you'll explore those benefits in this chapter. For those of you who don't own Photoshop, this is a great chapter to review and help guide you in deciding if Photoshop is a necessity for your workflow. When you're familiar with how Nik works within Photoshop, we'll work together on a few images to help build upon that foundation.

You'll also explore the pros and cons of using Smart Objects to manage your file. This concept can be a bit advanced, so I've created a video at www.peachpit.com/nik/smartobjects.mov to help explain Smart Objects. Now let's explore how Nik works inside the Photoshop application.

Using Selective Tools

One of the major benefits of using Photoshop with Nik plugins is that you can take advantage of the Selective Tools panel (**FIGURE 7.1**).

The tool panel lists all the Nik plugins that are currently loaded on your computer in order of suggested use. To start using any of the plugins while you're in Photoshop, click the triangle to the left of the desired filter name, and then click the plugin's name. For Dfine and Color Efex Pro (CEP), you'll be presented with the application as well your favorite presets.

FIGURE 7.1 Launch Nik plugins from Photoshop using the Selective Tools panel.

FIGURE 7.2 All your Favorites and Recipes are available with one click.

For example, if you click the triangle to the left of Color Efex Pro 4, you're presented with the program as well as all of your previously starred Favorites and Recipes (**FIGURE 7.2**). If you click your desired filter effect, such as the Tonal Contrast filter, Nik launches the plugin and brings you directly to that filter (**FIGURE 7.3**).

After you've launched the program and opened your image into any Nik Software plugin via Photoshop, you'll have the option of clicking OK to Fill the image with the filter effect applied to the entire image as a layer or selecting the Brush button to brush on the filter effect. Keep in mind that the Brush tool is available only when it's used in Photoshop; it doesn't work in Adobe Lightroom or Apple Aperture (**FIGURE 7.4**). The first option is straightforward: Click OK and your chosen filter effect is saved by default as a separate layer. The second option is a bit more flexible and allows you to brush on the effect using a filter mask. Let's discuss option two a little further.

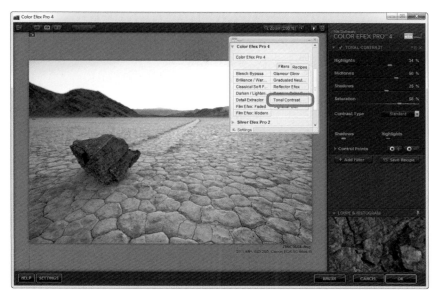

FIGURE 7.3 Selecting your desired filter in CEP will take you directly to that filter.

FIGURE 7.4 The Brush tool is available only when used in conjunction with Photoshop.

After you click the Brush button, the plugin saves the image as a layer with a mask. You're then presented with the Paint mode portion of the Selective Tools panel (**FIGURE 7.5**).

Paint Button

Click the Paint button to paint the filter's effect on the active layer. You can increase the size of the brush by pressing the left bracket key ([) or decrease the size of the brush by pressing the right bracket key (]). You can control the strength of the filter effect being applied to the image by altering the opacity of the brush.

FIGURE 7.5 Use the Paint tool to apply, remove, or discard filter effects on an image.

> **HOT TIP**
>
> You can change the opacity of the brush quickly by using your number keys: 10=10%, 20=20%, and so on.

Erase Button

Click the Erase button to remove the effect from a desired area. Just remember to click Paint again when you want to start applying the filter effect to the image.

Fill Button

The Fill button applies the filter to the entire image. This can be very beneficial when you want the majority of the image to receive the effect of the filter but want to remove the filter effect on only a small portion of the image. To remove some of the effect, click Fill, click Erase, and remove the areas of the image that you don't want to receive the filter's effect.

Clear Button

The Clear button is what I like to think of as the Oops button! (Some of you might have a different name.) Click this button when you've made a mistake and need to clear the filter's effect before you start painting again.

Apply Button

Click Apply when you've finished painting your image and want to apply the filter's effect to the image.

Discard Button

Click Discard when you want to start over. This button prevents the filter's effect from being applied and takes the image back to its previous state. I like to think of this button as a reset button.

Using Nik in Photoshop

You may be wondering why you just went through an exercise of painting on a filter's effect versus just using Control Points. It's true, Control Points are very powerful, but sometimes it's easier and more effective to apply adjustments globally, such as applying Dfine to reduce noise in the entire image and then brushing the effect on the exact area of the image where you want it, such as a bright blue sky. In addition, brushing on an effect allows you to have more control over the opacity of the application as well as the blending modes. If you know exactly what you want to do with an image, brushing on an effect can also save you time.

Now that you have a general idea of how to work with Nik's filters in Photoshop, let's move forward and process an image using a few of my favorite filter combinations.

Creating a Dynamic Landscape

One of my favorite places to photograph in the United States is Death Valley because the scenery is surreal, the sunsets and sunrises are breathtaking, and best of all it doesn't get super crowded. The image you'll work on is a sunset from Dante's Peak at 5475 feet overlooking Death Valley and the Badwater Basin. The goal with this image is to make it pop a bit, while increasing the overall contrast in the image. Although I shot this image at a very low ISO, there's still a small amount of noise that needs to be reduced from the sky. Be sure to register your book and download the image Dantepeak.tif at www.peachpit.com/nikplugin.

1. Select the Sky preset from the Dfine Selective Tools panel (**FIGURE 7.6**). Behind the scenes, the plugin creates a noise reduction profile (refer to Chapter 1) for you to apply to the image using the Brush tool. Begin brushing the effect on the sky while trying to avoid the mountains and areas where you want to maintain detail. Remember that the mask will show you how the filter is being applied. A simple way to remember what areas are being affected is to repeat the mantra "white is on (areas being effected) and black is off (areas not being affected)."

FIGURE 7.6 Paint the filter's effect onto the sky.

2. Let's go a bit out of sequence and jump to Color Efex Pro, and apply a Graduated Neutral Density (ND) filter before heading into Viveza (**FIGURE 7.7**). Handling the Graduated Neutral Density aspect now will help you balance the exposure between the foreground and background before adding saturation to the sky using Viveza.

3. Using the Graduated Neutral Density filter, darken the Upper Tonality (sky) by moving the slider to the left and lighten the Lower Tonality (mountains) by moving the slider to the right just a tad. Then reduce the blend just a bit by moving the Blend slider to the left. In effect, by reducing the blend you're basically creating more visible contrast between the foreground and background. Click OK to apply the filter to the entire image (**FIGURE 7.8**).

FIGURE 7.7 Using the Graduated ND filter, you'll darken the sky while lightening the foreground.

FIGURE 7.8 Use the Graduated ND filter to control the exposure of the foreground and background.

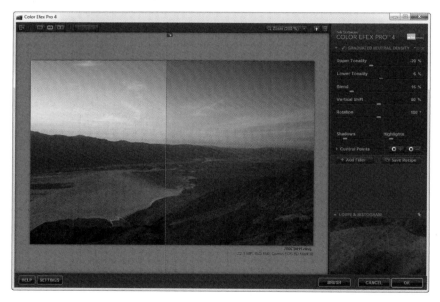

4. Open Viveza, adjust the colors, and add structure using Control Points. In this case you'll add one control point to the blue sky and increase the saturation just a touch. Place another control point in the orange area of the horizon and warm it up using the Warm slider. To add some texture and definition to the salt flats, drop a control point on the flats and increase the structure (**FIGURE 7.9**).

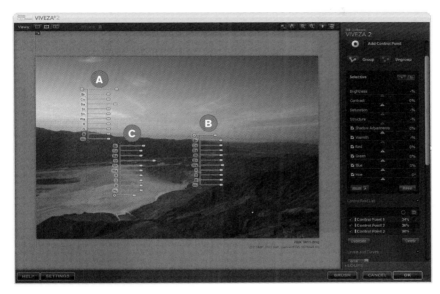

FIGURE 7.9 Use Control Points to help isolate the areas that will receive the filter's effect. Add a control point to the blue sky and increase the saturation (A). Place another in the orange area of the horizon and warm it up (B), and add texture and definition to the salt flats by adding a control point and increasing structure (C).

5. Click the Brush button and begin painting these effects on your image. Try to avoid any application to the mountains. Painting on filters where control points are present adds another layer of control over the application of the effect to an image. You can use your mask as a reference to make sure you're applying the filter to the correct locations (**FIGURE 7.10**).

FIGURE 7.10 Reference your mask to make sure you're painting the areas you intend to apply the filter to.

6. Apply what I call the WOW filter—the Tonal Contrast filter. Open Color Efex Pro and add this one to your Favorites by clicking the star next to it. This filter's default settings have already made a huge improvement to the image by increasing the microcontrast. Notice how the mountains are almost popping off the screen. Increase the Highlights slider so you can draw a little more attention to the clouds as well as the salt flats. Click OK to save this effect to the entire image (**FIGURE 7.11**).

FIGURE 7.11 Use the Tonal Contrast filter to add dimension to an image.

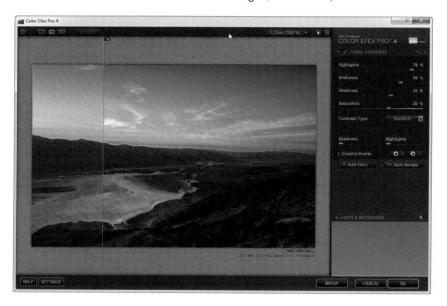

7. Review your image and make any tweaks you feel are necessary. One of the common problems that can occur along the way, and especially when you're darkening a sky with the ND filter, is that previously unnoticed dust spots become very apparent. Be sure to clean up those spots using the Heal tool as you find them. For this image, the biggest adjustment at this point is to reduce the Opacity to 80% so that it has an overall more natural-looking feel (**FIGURE 7.12**).

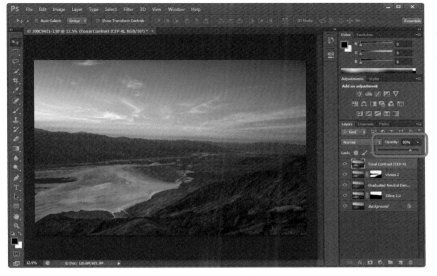

FIGURE 7.12 Use the Opacity slider to make adjustments to the strength of the filter's effect and to make sure your image looks natural.

If you're satisfied with the image, save the file with all the layers intact so that you can refer back to it at a later date. Or you can flatten the file to save space, but in doing so all the layers will be discarded. For images I know I'll be referring back to, I save them with the layers intact, and all others I'll flatten to save space. To flatten a file, choose Layer > Flatten or press Shift+Ctrl+E (Shift+Command+E).

What Is a Smart Object?

Whenever you apply a filter in Photoshop, it creates a permanent change to the image's pixels. However, when you use Smart Objects, you can perform nondestructive editing (such as crop, rotate, etc.) to an image, including applying nondestructive filters, such as Nik Software's plugins. Using Smart Objects allows you to revisit your image and make countless adjustments to a filter's effects as often as you desire without affecting the original image. However, the downside to this flexibility is a massively large file. For this reason, I don't edit every image as a Smart Object; instead, I select certain special images that I intend on using over and over. For example, if I plan on displaying an image online, selling it in the gallery, or reworking it in the future, I'll process it as a Smart Object. Let's review the very basics of opening an image in Lightroom or Photoshop as a Smart Object.

To open an image as a Smart Object in Lightroom, all you need to do is right-click the image and choose Edit In > Open as Smart Object in Photoshop. This command will copy the image and open it as a Smart Object in Photoshop (**FIGURE 7.13**).

To open an image as a Smart Object in Photoshop, choose File > Open as Smart Object. Then locate the image on your hard drive that you want open as a Smart Object (**FIGURE 7.14**).

FIGURE 7.13 Right-click the image that you want to open as a Smart Object in Photoshop.

FIGURE 7.14 Use Smart Objects when you want to revisit your edits in a nondestructive environment and when file size is not an issue.

Another benefit to opening your image as a Smart Object in Photoshop is that you'll be able to revisit your Camera RAW setting as often as you want, no matter where you are in your workflow. This is not the case with Lightroom or Aperture because you're able to make adjustments to the RAW file only prior to exporting the image into the plugin (**FIGURE 7.15**).

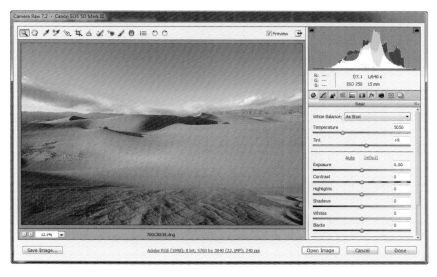

Using Smart Objects with Nik

One of the major benefits of using Smart Objects with Nik is that you're able to reopen a filter and pick up exactly where you left off, with all the plugin's sliders in the exact place where you left them when you saved the image the last time. Let's explore this further by examining an image that has been opened as a Smart Object in Photoshop (**FIGURE 7.16**).

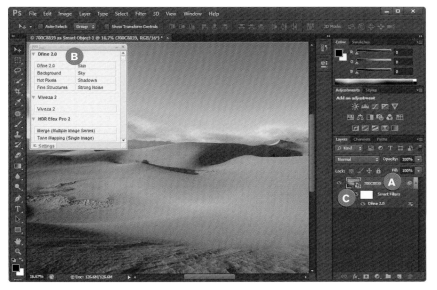

FIGURE 7.16 Smart Objects allow you to nondestrucively edit an image again and again. Notice that the image has been properly converted, which is indicated by the presence of the Smart Object icon (A). Launch Dfine by clicking it in the Selective Tools panel (B) and review your filter mask (C).

1. Look at the bottom right of the layer preview to make sure that the image has been properly converted to a Smart Object, as indicated by the Smart Object icon.

2. Launch Dfine by clicking it in the Selective Tools panel.

3. Make the desired edits.

 After using the plugin, Dfine applies the Noise Reduction effect to the entire image using a Smart Filter mask, as indicated by the white box (recall that white means the effect is turned on and black means the effect is turned off). I'll address how to paint an effect onto a layer in the next few pages.

Keep in mind that at any point in your workflow you can make alterations to the original RAW file in Camera RAW simply by double-clicking the Smart Object thumbnail layer. The benefit of doing this is that you can decide to make some adjustments to the exposure or perform some highlight or shadow recovery adjustments, which in turn will update the Noise Reduction mask as well.

WHAT CAN AND CAN'T SMART OBJECTS DO?

Smart Objects *can* scale, skew, rotate, and warp nondestructively, and apply nondestructive filters.

Smart Objects *cannot* burn, dodge, paint, clone, or apply the Heal brush.

Using Smart Filters

Smart Filters allow you to apply effects without permanently changing the original image. Simply put, your original data and pixels are protected as long as you are working within a Smart Object and using Smart Filters. But there are downsides to this added flexibility. As mentioned earlier, there are more layers to manage and remember, plus the file size can become quite large. The trade-off of a large file size is the additional flexibility of being able to reedit an image. Let's review the advantages of using a Smart Filter.

Revisiting a Smart Filter adjustment

One of the biggest advantages of Smart Filters is being able to reopen a Nik filter and continue to make adjustments from where you left off. To do this, locate the filter's name in the Smart Filter list and double-click it (**FIGURE 7.17**).

Note how your Global and Selective Adjustment sliders (including your control points) are exactly as they were when you last saved your image. This means you can adjust the sliders again without having to remember the amount of structure you used or where you placed the control points. The only missing piece is the detail of your edits in the plugin's History browser, but this is a small price to pay for the additional

FIGURE 7.17 Smart Filters allow you to open Nik filters to their last known edit state by double-clicking the filter's name.

flexibility. When you're done making edits to the filter, close the filter, and your Smart Filter will be updated in Photoshop.

Blending and Opacity

My second favorite Smart Filter feature is the ability to make adjustments to the opacity of the filter or change the blending mode. To do this, click the symbol (two triangles) to the right of the Smart Filter's name (**FIGURE 7.18**).

A Blending Options dialog box opens, allowing you to make whatever adjustments you feel necessary. Often the only adjustment I make is to the opacity of the filters. Remember that opacity means how much of the filter's effect will be applied to the image. The default is 100%, so if you want to reduce that amount to half, move the Opacity slider to 50% (**FIGURE 7.19**).

FIGURE 7.18 Click the trangle to edit the blending options and opacity.

FIGURE 7.19 Change the strength of the filter by adjusting the Opacity slider.

FIGURE 7.20 Use different blending modes to create unique, stylized adjustments to your filter.

FIGURE 7.21 Increase saturation and structure on an image using Viveza.

Although I don't use the blending options very often, they can be effective tools when you're using some of the other Color Efex Pro filters. To adjust the blending mode, click the Mode drop-down menu and choose from the 27 different blending modes (**FIGURE 7.20**).

Inverting the mask

A third Smart Filter feature I know you'll love is the ability to paint a filter's effect on a desired area using a filter effects mask. When you're using a Smart Object, unlike when you're using layers, when you apply a Nik filter effect in Photoshop, by default it creates a white filter effects mask instead of a black mask. This white mask means the entire area of the image is receiving the filter's effect. You can control which areas receive the filter effect by painting on black and erasing areas you don't want to receive the effect. Or, by using my preferred method, you can invert the filter mask so that no areas receive the filter, and then paint in the areas you want to receive the filter's effect. The reason I prefer the latter method is that it's easier to remember to paint in what you want to see versus what you don't want to see. Let's explore this further by using an example of an image that's had saturation and structure enhancements made to the sky using Viveza (**FIGURE 7.21**).

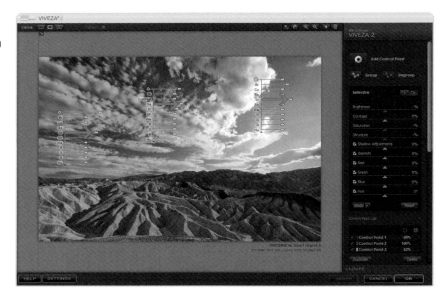

By default, you're unable to brush on an effect when you're editing an image as a Smart Object in a Nik plugin. Instead, you must save the image back into Photoshop where you're presented with a white filter effect mask, which means the entire area is receiving the filter's effect. You then need to invert the mask layer so you can focus on painting in the areas you want to receive the filter's effect. To do this, select the filter effect mask and double-click it. You'll be presented with the filter's Mask Properties dialog box. Click the Invert button (**FIGURE 7.22**). Or you can skip the dialog box and just select the mask with your cursor while pressing Ctrl+I (Command+I).

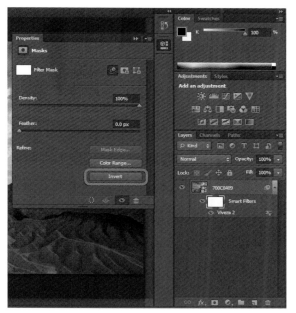

FIGURE 7.22 To invert the mask, use the keyboard shortcut Ctrl+I (Command+I).

When the mask has been inverted (indicated by the black filter mask), start painting in the area of the image where you want to apply the filter effects. To start painting, you need to select a brush by pressing B on your keyboard. You can use a fairly large brush on this image because you'll be painting primarily in the sky (**FIGURE 7.23**).

FIGURE 7.23 Press B to select the Brush option.

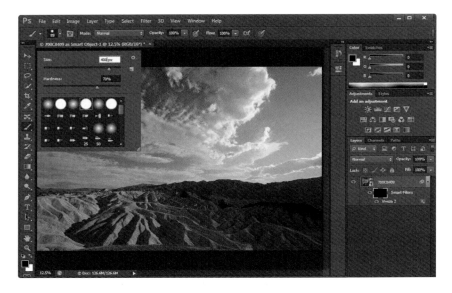

As you paint the sky, you'll notice the filter's effect being applied to the image. Also notice how the sky is popping with color and structure compared to the original in Figure 7.22. If you make a mistake, you can always switch so that you're painting the background back in by pressing the letter X on your keyboard. After you've made the correction, press the letter X again so you can start painting and reapplying the filter's effect (**FIGURE 7.24**).

Eventually you'll need to use a smaller brush to touch up near the mountains. To adjust your brush to make it smaller, press the left bracket key ([); to increase your brush, press the right bracket key (]).

HOT TIP

Turn filter effects on and off by clicking the eye icon to the left of a filter or mask layer to show (turn on) or hide (turn off) the effect.

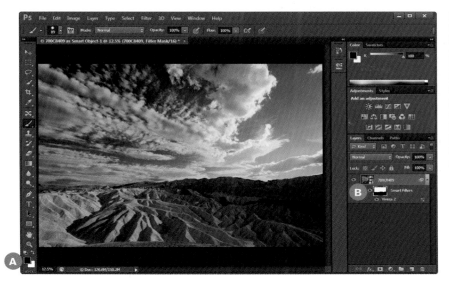

FIGURE 7.24
Review the Smart
Filter mask to confirm
proper filter applica-
tion. Press the X key
to toggle between the
foreground and back-
ground (A). White rep-
resents the area of the
image where the filter
has been applied; the
black area represents
zero application (B).

Apply Filters Independently Using Smart Objects

Smart Objects and Smart Filters create a
tremendous amount of flexibility, but one of
the most frustrating limitations is the inability
to create multiple filter masks. This means that
no matter how many filters you have stacked
(applied), all of them will share only one mask
(**FIGURE 7.25**). Keep in mind that you can still
change the blending mode and opacity, and
even turn filters on and off, but you cannot
brush on a single filter effect independently of
the others. Fortunately, there's a workaround!

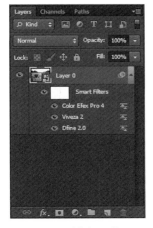

FIGURE 7.25 All three filters
share one filter mask.

All you need to do is select and then right-click
the original Smart Object layer to create a new
Smart Objects layer. This basically embeds
the other Smart Filters into the original Smart
Object layer and creates a new Smart Object layer. You can then paint a new
filter effect onto the layer, building upon your previous edits. If at any point

you want to edit the previous edits, right-click the Smart Object and choose Edit Contents (**FIGURE 7.26**).

FIGURE 7.26 You must edit the contents of the Smart Object in order to work on previously edited filters.

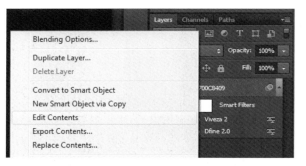

Creative Editing with Smart Objects

Now that you understand the basics of how Smart Objects work, let's work together on a portrait. As a photographer, whenever I encounter a unique-looking face with lots of lines and texture, I almost always convert it to black and white using the technique I'm about show you. This technique does a nice job of highlighting texture and contrast, and bringing out detail in a face. I had the pleasure of photographing this wonderful gentleman during an afternoon of street photography (**FIGURE 7.27**). The image has already been converted to a Smart Object as noted by the "page" icon that's been embedded in the image's thumbnail, located in the Layers panel.

1. Click the Bleach Bypass filter in the Color Efex Pro tab in the Selective Tools panel (Figure 7.27). Bleach Bypass is listed as a preset in the Color Efex Pro tab because I've starred it as one of my favorites.

 Bleach Bypass automatically makes an image darker via desaturation and by adding contrast.

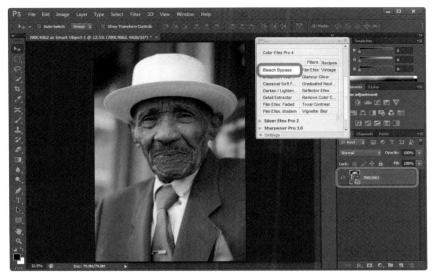

FIGURE 7.27 Locate your image's thumbnail in the Layers panel to confirm that your image has been converted to a Smart Object.

2. Move the Brightness slider to the right and add some saturation back to the image to counteract the filter's effect and to brighten the image a bit. You do this because the next step is to take this image into Silver Efex Pro, and you want to have some color to work with when you make adjustments in that plugin (**FIGURE 7.28**).

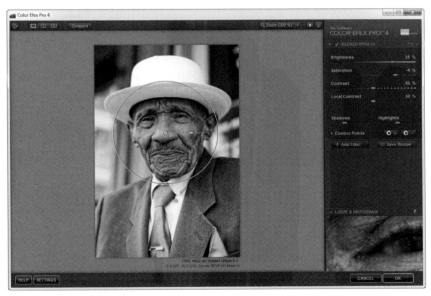

FIGURE 7.28 The Bleach Bypass filter increases contrast and details.

3. Increase the Shadows and Highlights sliders to help bring back some of the lost details to the hat as well as the gentleman's face because of all the texture in those regions.

4. Drop a control point in the center of his face and dial back the Opacity a bit so the Bleach Bypass process isn't overdone (**FIGURE 7.29**). Click OK to save the file back to Photoshop as a Smart Filter.

FIGURE 7.29 Use the Opacity slider to control the strength of the effect.

5. In Photoshop, launch Silver Efex Pro by clicking it in the Selective Tools panel. The reason I skipped using a preset is because the Bleach Bypass process has already added a lot of texture to this image, and using another preset would just complicate things. Instead, you'll tackle this image by using Control Points and addressing a few problem areas while adding some style. In addition, because this gentleman has a nostalgic look, it makes sense to try to mimic the look and feel of film while you're at it (**FIGURE 7.30**).

FIGURE 7.30
Silver Efex Pro mixed with the Bleach Bypass filter creates a very unique style.

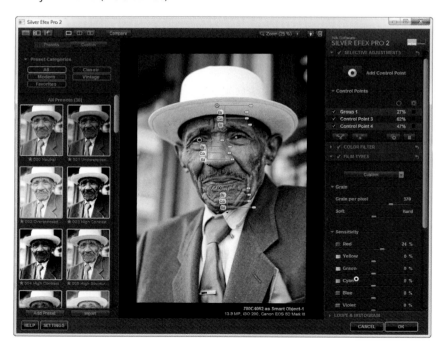

Fixing the dark regions

The regions around the man's eyes are a bit dark, so you need to drop two control points, one on each eye. Group these control points by selecting them and clicking the Group Control Point button. Then increase the exposure a bit as well as the structure.

Adding texture

The Bleach Bypass process has already done a great job of adding detail to the existing textures. However, a few small enhancements could be made to the texture by placing a control point on the brim of his hat and another on his chin. Increase the Structure slider just a tad to help boost the texture in these regions.

Adding grain

You can give this image a film look by increasing the appearance of the grain. To do this, move the Grain per pixel slider to the left to increase the grain.

Lightening skin tones

You'll want to lighten the skin tones a bit by increasing the Red slider just enough to help with the exposure.

Save the file back into Photoshop as a Smart Filter by clicking OK.

Adding some final adjustments

You're almost finished, but there are a few more adjustments to make before calling it good.

1. Go back into Color Efex Pro. You'll use the Darken/Lighten Center filter to apply a small vignette to the image.

2. To do so, you first need to use the Place Center tool to identify the area you want to focus on (**FIGURE 7.31**). Place the tool on the man's nose to tell the filter that this is the center point.

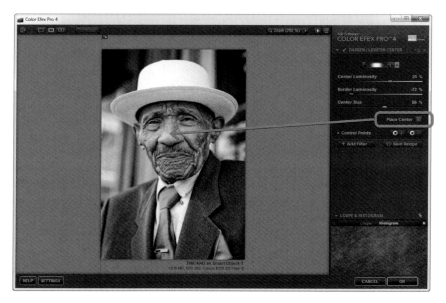

3. Darken the Border Luminosity by moving the slider to the left. This will create a very natural-looking vignette, and it does a really nice job of making the subject's jacket look richer in tone.

4. Click OK to save the filter effect back into Photoshop as a Smart Filter.

5. Review the image and see if there are any changes you want to make. Because you're working with Smart Objects, you're able to select any one of the filters and rework the image exactly where you left off. Also, you can hide a filter's effect simply by turning off the Smart Filter's visibility by clicking the eye icon to the left of the filter's name (**FIGURE 7.32**).

6. If the image looks good, open Sharpener Pro to apply sharpening for your output. The nice thing about using Sharpener Pro as a Smart Object filter is that you can repeatedly alter your output intentions while maintaining a nondestructive file (**FIGURE 7.33**).

The sky is the limit when it comes to Nik Software plugins. It's through experimentation that you truly come to understand the depth of all the Nik plugins. Processing should be fun, but it's not always a smooth ride. I've made my fair share of mistakes, but it's through those mistakes that I've found some real gems and my own style. Good luck, have fun, and here's to some smooth landings!

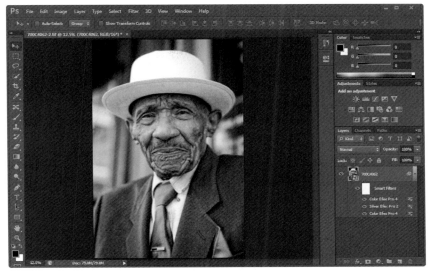

FIGURE 7.32 Show or hide a Smart Filter's effect by clicking the eye icon to the left of the filter's name.

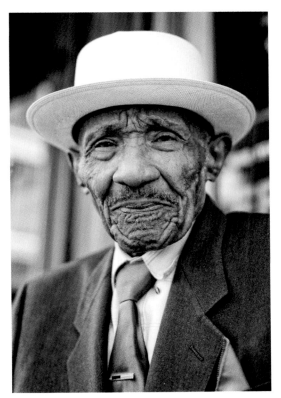

FIGURE 3.33 Here is the final processed image.

Index

Eyedropper tool (Viveza), 32
 color adjustments and, 36–37
 control points and, 35
eyedroppers
 noise reduction, 18, 19
 selective sharpening, 176, 177, 187

F

Favorites category
 Color Efex Pro, 52
 HDR Efex Pro, 142
file management, 82
Fill button, 24, 192
Film Efex filters, 74–75
Film Strength slider, 75
Film Type options
 Color Efex Pro, 75
 Silver Efex Pro, 102, 107
Filter Categories Selector, 52
Filter Color slider, 62
Filter Control menu, 58–59
filter effects mask, 202–205
Filterlist, 52–53
filters
 adding, 58
 brushing on, 190, 195
 categories for, 52–53
 deleting, 59
 example of using, 76–79
 hiding/showing effects of, 58, 204, 210, 211
 options for resetting, 59
 Smart Objects and, 205–206
 stacking, 59, 76–79
 See also color filters; Smart Filters
Fine Structures brush, 22

Finishing Adjustments (Silver Efex Pro), 104–106
 quick tips on, 105
 toning images, 104, 107
 vignettes, 105
Finishing panel (HDR Efex Pro), 154–155
flattening files, 197
Focus slider, 184

G

Ghost Reduction feature, 139, 156
ghosting in images, 131, 138, 139, 156
Glamour Glow filter, 69–70
Global adjustments
 Output Sharpener filter, 183–184
 RAW Presharpener filter, 172–173
 Silver Efex Pro, 94–95
 toggling between Selective and, 33
 Viveza, 29–32
Glow slider, 70
Glow Warmth slider, 70
Gold reflector effect, 76
golden hour photos, 155–160
Google and Nik Software, xi
Graduated Neutral Density filter
 Color Efex Pro, 70–72, 194
 HDR Efex Pro, 154, 159
grain effect, 209
Grain Per Pixel slider
 Color Efex Pro, 74
 Silver Efex Pro, 102
grainy images, 1, 2
green filter, 101
Green Preview mode, 11
Green slider, 31
grouping control points, 34, 61, 96
Grungy slider, 150

H

Halftone setting, 182
Hand tool, 10
Hard/Soft slider, 102
HDR Efex Pro 2 (HEP2), 127–161
 Alignment check box, 138
 Chromatic Aberrations check box, 140
 Color adjustment panel, 153, 158
 Control Points used in, 153, 159
 creating HDR images in, 128
 Custom Preset Library, 142
 example of using, 155–160
 exporting images into, 136–137
 Finishing panel, 154–155
 Ghost Reduction feature, 139, 156
 golden hour photos and, 155–160
 History browser, 144–145
 hot tips on using, 139, 142, 143, 152, 158
 importing presets into, 143
 interface overview, 140–155
 left panel adjustments, 141–145
 Merge Dialog interface, 137–140
 Preset Library panel, 142
 Preview Brightness slider, 138
 right panel adjustments, 146–155
 Selective Adjustments panel, 153
 Tonality adjustment panel, 152–153, 158
 Tone Compression panel, 147–151, 157
 top menu settings, 145–146
HDR photography, 127–161
 approaches to creating, 128–130
 best practices for, 130–132
 color space setting for, 135
 Detail Extractor filter and, 68–69
 dynamic range and, 128
 golden hour shots and, 155–160
 hot tip on shooting, 132
 image management for, 133–134
 top ten tips for, 161
HDR.tif image files, 155
HEP2. *See* HDR Efex Pro 2
hiding/showing
 adjustment panels, 56, 90
 filter effects, 58, 204, 210
high dynamic range images. *See* HDR photography
High Structure (smooth) preset, 109, 112–113
high-key images, 115, 116–117
Highlights slider
 Color Efex Pro, 59, 60
 Graduated Neutral Density filter, 71, 72
 HDR Efex Pro, 152
Highlights Tonality Protection slider, 120
histogram
 bracketing exposures using, 161
 tonal analysis using, 84
History browser
 Color Efex Pro, 55–56
 HDR Efex Pro, 144–145
 Silver Efex Pro, 91
 Undo button vs., 56, 144
History State Selector
 Color Efex Pro, 55
 HDR Efex Pro, 144, 145
 Silver Efex Pro, 91–92
Hot Pixels brush, 22
hot tips
 AEB camera mode, 132
 Color Efex Pro, 53, 54, 72, 73
 HDR Efex Pro, 139, 142, 143, 152, 158